To Ben

Merry Christmas

Love,

Grandma & Grandpa

Perry

Spirit Bear

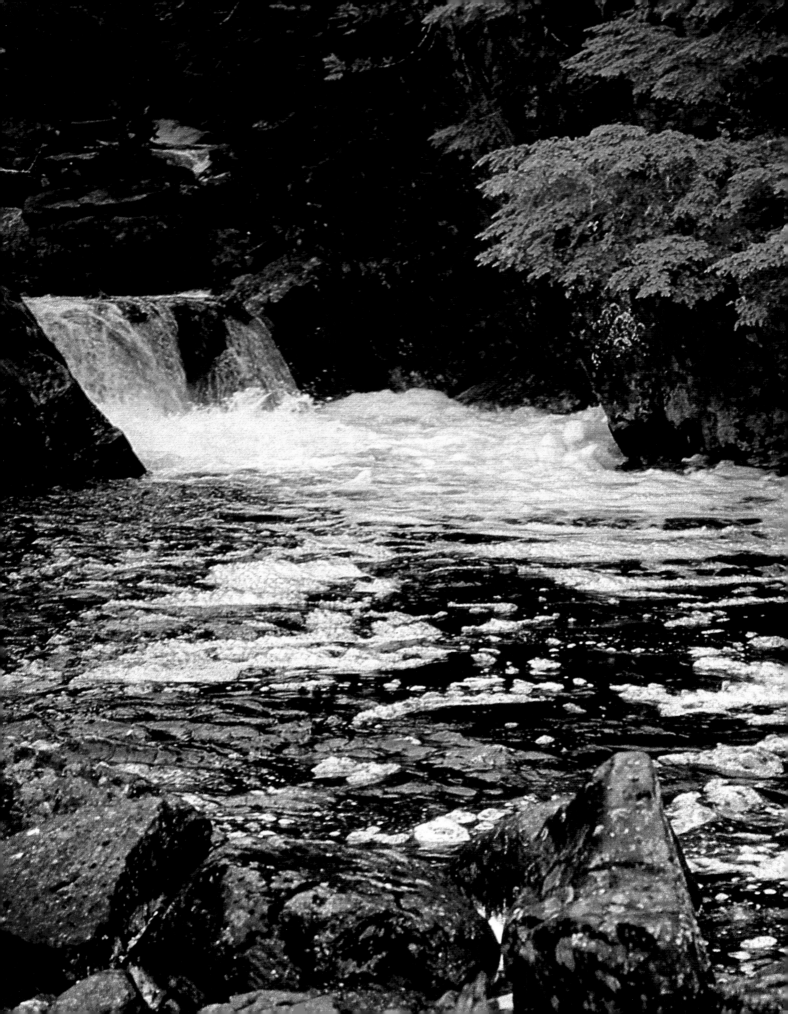

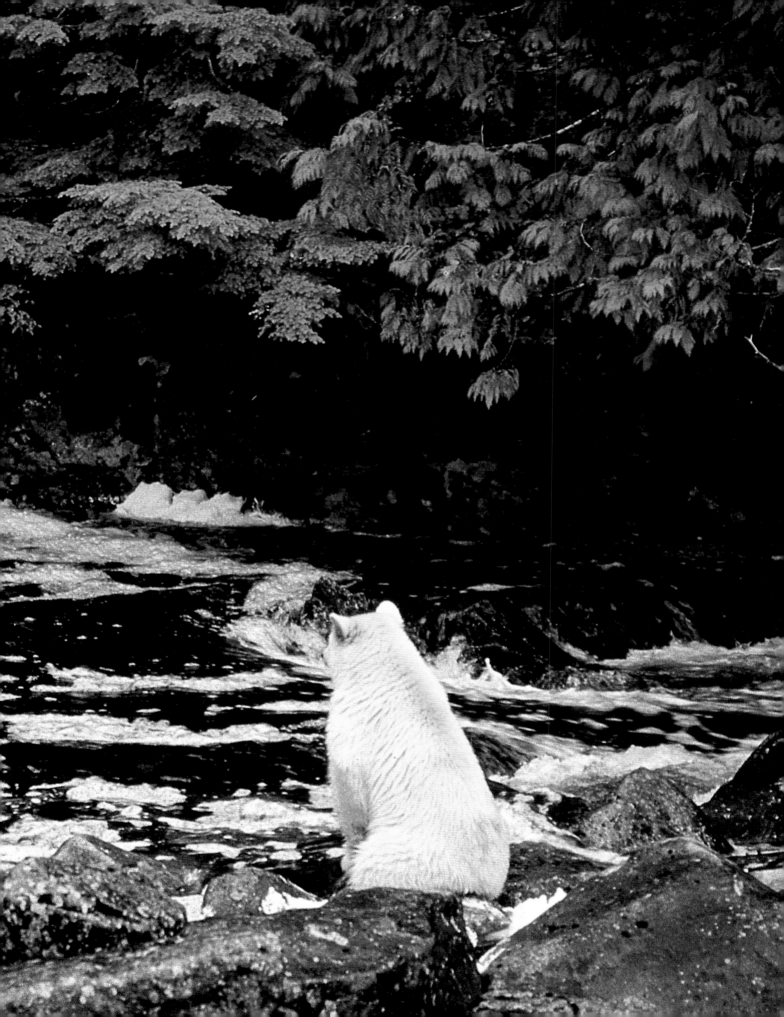

▼▼▼▼▼▼▼▼▼▼▼▼▼▼▼▼▼▼▼▼▼▼▼▼▼▼▼▼▼▼

Spirit Bear

ENCOUNTERS

WITH THE WHITE BEAR OF THE

WESTERN RAINFOREST

Text and Photographs by
Charles Russell

Foreword by Andy Russell

KEY PORTER BOOKS

To Maureen,
who convinced me that I should write this book.

All photographs are by the author except where noted in the captions.

Canadian Cataloguing in Publication Data

Russel, Charles
Spirit Bear: encounters with the white bear of the western rainforest

Includes index.
ISBN 1-55013-595-3 1-55013-649-6 (pbk.)

1. Black bear - British Columbia - Princess Royal Island. 2. Bears.
3. Wildlife cinematography - British Columbia - Princess Royal Island.
I. Title.

QL737.C27R87 1994 599.74'446'097111 C94-931284-3

Key Porter Books Limited
70 The Esplanade
Toronto, Ontario
Canada M5E 1R2

Distributed in the United States of America by National Book Network, Inc.
1-800-462-6420

The publisher gratefully acknowledges the assistance of the Canada Council and the Ontario Arts Council in the publication of this work.

Design: Peter Maher
Front Jacket photograph: Charles Russell

Printed and bound in Spain

95 96 97 98 98 99 6 5 4 3 2 1

Contents

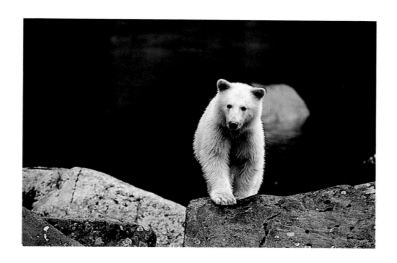

Foreword

CHARLIE RUSSELL, MY SECOND SON, HAS been destined to be associated with bears from the time he was born. When he was about a month old, his mother left him sleeping in his carriage on the verandah of our cabin one fine morning. While she was inside, a black bear came out of the trees close to the house and went up on the porch. It didn't disturb Charlie but retreated back into the bush, leaving some dirty tracks on the step.

Charlie, with his sister and three brothers, grew up in bear country. The only advice we gave them was never run from a bear, and it was good advice, because they experienced many close encounters with both black and grizzly bears in their growing years.

In 1961, Charlie and his brother Dick joined me to begin a three-year film study of grizzly bears in the best grizzly country we could find in Alberta, British Columbia, Yukon Territory and Alaska. There are those that think that true exploration in North America is a thing of the past. Not so, for there is a whole world of exploration waiting in the realm of nature which has never been fully investigated. At that time we all shared the fascinating experience of exploring the life of a much misunderstood animal and the wild country in which it lived. Charlie, always daring and adventurous, enjoyed himself immensely and helped obtain footage that would eventually become the first film to demonstrate that man and the grizzly could live together. For the last two years of that effort, we not only obtained some outstanding 16-mm color film recording the big bears at close range, but we also did so completely unarmed except for our cameras.

I recall Charlie celebrating his twenty-first birthday by taking a hike alone up into the mountains. Dick and I were watching him through our binoculars about one-and-a-half miles (2 km) away as he walked up the incline of a hogback ridge. Suddenly a grizzly showed up below him and began climbing toward him. Charlie stopped and photographed the bear as

it approached. Then the grizzly stopped and obviously the two of them were sizing each other up. After a moment, Charlie moved on along the crest of the ridge with the bear traveling at a walk a bit below and to one side until the contour of the country hid them both. Needless to say, Dick and I were left wondering what eventually happened, until along about sunset, we saw Charlie coming across the flat to camp. He was ecstatic as he told us about his day of adventure and, what was even better, his film record of it.

When Charlie undertook to help film and photograph the little-known Kermode bear on Princess Royal Island, he brought to his work years of experience. His extensive knowledge of bear country and bears enabled him to develop a personal connection with one of the bears on the island — a connection that, to my knowledge, no other person has ever accomplished. The result of his work with the Spirit Bear is this beautiful book.

ANDY RUSSELL

It is with some reservation that I list only my name as author of *Spirit Bear* because there were many people without whose help this book would not have become a reality.

For the difficult process of outlining, typing, editing and proofreading the manuscript, I'm indebted to my best friend Maureen Enns, my brother Dick Russell, Myrna Shapter, Laurie Coulter, Meg Taylor and Valerie Haig-Brown.

For professional advice and encouragement, I would like to thank my two scientist brothers Dick and John Russell.

I'm also indebted to Jeff and Sue Turner, whose project it was in the first place, and to my father Andy Russell who got me started in photography and introduced me to grizzly country at a very young age.

Early Years

I WAS BORN AND RAISED ON A BEAUTIFUL ranch in the southwest corner of Alberta, Canada. It was markedly wild country when I was a child, and some of that wildness remains today. The ranch lies along the northeast boundary of what is now Waterton Lakes National Park. It's good cattle range but even better bear habitat. Although there are meadows, the land is peppered with dense willow, muskeg and wind-gnarled aspen.

My maternal grandfather, Bert Riggall, arrived fresh from England in 1904. The son of the mayor of Grimsby, a town on the east coast of England, he had been working on a degree in medicine when the urge to travel around the world came upon him. Needing money by the time he arrived in Calgary, he found a job with the original land survey crew working in the southwest corner of the province. This area so appealed to him that he decided to take up a homestead and settle there with his new bride Dora, an Irish woman who had cooked for the survey crew.

Bert Riggall's choice of homestead had more to do with his interest in its wildlife than his desire to become a farmer. Many of the early homesteaders in this rugged area were hard put to make a living solely off the land. The high elevation, severe weather and short frost-free growing period pretty well limited the crop options to hay and oats. Bert and Dora decided to make the most of the dramatic and wild land in which they lived. Beginning in 1910, they developed a guiding business for well-to-do clients from the eastern United States. In the early years, guiding hunters through the mountains on horseback was the backbone of the business, but my grandfather had other talents which soon surfaced. Within a few years, he was widely sought out for his skills as a botanist, naturalist and photographer. His concerns about conservation soon led to his involvement in the expansion of Waterton Park in 1914, even though the new boundaries encompassed what had been his hunting territory. Grandfather's interest in natural history and conservation long before they

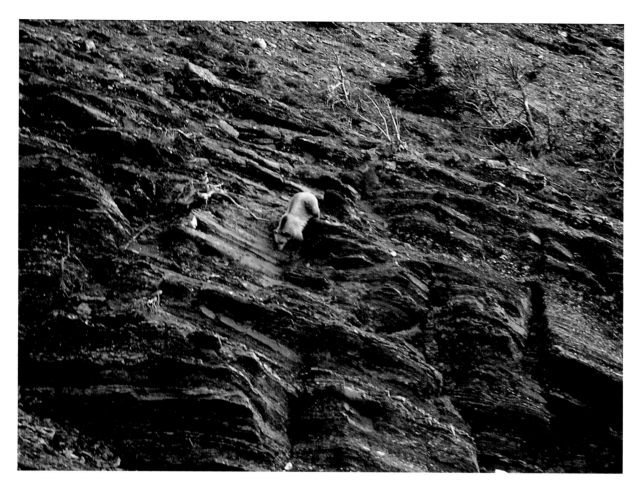

became "fashionable" served as an inspiration to succeeding generations of his family.

Grandfather died when I was only eighteen, but by then he had had a profound impact on my thinking and interests. I spent many exciting hours with him in his darkroom. The magic of watching by the red glow of the safelight as images appeared in the wash of chemicals got me interested in photography at a very young age.

Strange to say, when it was first established Waterton Park had far less wildlife than it does today. The last mini ice age had ended around 1850 and the ecosystem's plant and animal communities were still adjusting. As well, hunting by aboriginal peoples and immigrants had escalated around the turn of the century, following the decimation of the buffalo herds on the prairies. Moose and wapiti (elk) had been virtually eliminated, and mountain sheep became scarce. A few grizzly and black bears remained, but these were confined to the relatively inaccessible mountains and foothills. The campaign to eliminate the grizzly from "cattle country" had long before killed off the once numerous plains grizzly.

When I took this photograph, I didn't realize the grizzly was descending the cliff to get my friend Beth and me to move away from a carcass on which the bear had been feeding.

*Ranching in
grizzly country.*

Despite his interest in natural history and genuine inclinations toward
conservation ethics, Bert Riggall shared one thing with other pioneers: he
simply did not like or trust bears, especially grizzly bears. His stories were
full of mistrust of these animals. Indeed, I can't recall a single story where
the grizzly came out the winner in these tales of fearful conflict. There
were photographs of hunters and dead grizzlies on his walls, and bearskin
rugs adorned his floors. Needless to say, Grandfather didn't allow grizzlies
to wander freely on his property.

My family and I have often pondered this apparent inconsistency in
Grandfather's otherwise profound regard for nature. Why did he seem to
hate bears so? I believe that the hard life of the first European settlers
must have had something to do with it. It was not easy carving a life out of
the wilderness, and bears were seen as competitors for food and
potentially dangerous — a view that grew into mythical proportions
through much repeated and embellished campfire tales.

Reflecting the commonly held view of the grizzly at the time, in 1815
American naturalist George Ord assigned it the Latin name, *Ursus
horribilis.* He quoted the following description of the supposed fierceness
of this species of bear from H.M. Brackenridge's *Journal of a Voyage up the
Missouri River, in 1811:*

This animal is the monarch of the country which he inhabits. The African lion or the tiger of Bengal are not more terrible or fierce. He is the enemy of man and literally thirsts for human blood. So, far from shunning, he seldom fails to attack and even to hunt him. . . .

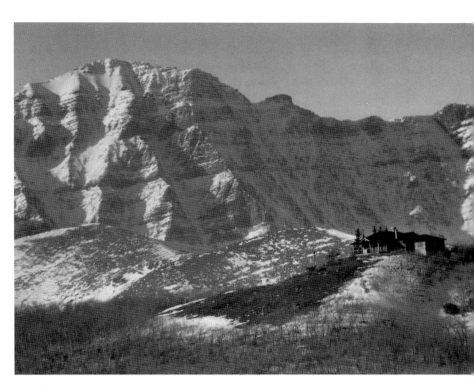

The Hawk's Nest in 1962.

Feelings toward the grizzly had not changed much in the hundred years since Ord had named it *Ursus horribilis*, and Grandfather was no exception to the rule.

My father, Andy Russell, began working for Bert in 1935, hiring on as a cowboy to help train the horses. Grandfather had doubled his horse herd to fifty, and many of the new recruits were unbroken to saddle or pack. Although each party of guests seldom exceeded ten, the average time spent in the wilderness was about three weeks, so the majority of the animals were used to carry the food, tents and personal gear.

Andy fell in love with Kay Riggall, one of Bert and Dora's two surviving children. The other three had all died in infancy, which was not unusual in the days before the advent of modern medicine. My dad married "the boss's daughter," and later bought the business from his father-in-law when Bert suffered a heart attack in 1946.

My siblings and I grew up in the guest lodge, which we called the "Hawk's Nest." It was perched upon a high foothill, giving us a commanding view of a unique part of the eastern slopes of the Rocky Mountains. In fact, I'd bet there are not more than a half dozen private dwellings in North America with a more splendid view from the front doorstep. The view is spectacularly beautiful because it is here that the prairies sweep right up to the base of the Rockies.

At a very early age, my brothers Dick and John and I entertained many fantasies about the mountains. The most long-standing one was that they were hollow. This theory developed from Mom's explanations of where Dad went on his long pack trips. She said he went "into the mountains." My young imagination had a wonderful time with that one! My brothers and I would be spellbound by Dad's stories whenever he returned. Many of his

A pack train led by my father leaves for a two-week journey "into the mountains."

tales featured bears, and we came to understand that the bears lived "inside the mountains" too. My older brother Dick was invited along on his first pack trip when he was seven years old. (Dad never inflicted more than one of us on his guests at a time.) I remember eagerly awaiting his return to hear a firsthand account of what the interior of the mountains was like. His stories, although revealing the truth about the mountains, were nevertheless full of wonder and excitement.

My parents insisted that, like Dick, I would have to wait until my seventh birthday before I could go on a pack trip. After a winter of persistent persuasion, I was able to knock a year off my wait. It was 1947. I was six years old and about to embark on three weeks of high adventure in incredible mountain country with my father, my one and only hero. This era of my life can only be described as idyllic.

The horse assigned to take care of me was called Blackie, which amused people who didn't know his history. As a young animal, Blackie had indeed been black but had slowly turned gray over the years until he was almost pure white when I finally rode him. Soon my independence and pride led to my refusal to be lifted into the saddle. I would maneuver Blackie over to a rock or log, and he would patiently put up with many a trial run as I sought to gain the necessary elevation to make it aboard. The real test of his patience came when I devised an ingenious new system to climb aboard: I knotted his tail into a rope ladder and used that to crawl up over his rear end to reach the saddle — a forerunner to the running leap I imagined would come later. It was from the back of this wonderful horse that I saw my first grizzly.

On that fateful day, Dad was taking his guests on a trip along the Continental Divide, which separates the Pacific and Hudson Bay watersheds, and British Columbia from Alberta. Even after forty-seven years, I have a vivid memory of that view to the west with ridge after ridge of mountain spines, each one less defined and a lighter shade of gray-blue as they faded into the distance. Somehow it felt different from anywhere I

had been before. The creeks flowed west instead of east, and as Dad explained that they emptied into the Pacific Ocean 500 miles (800 km) away, I imagined no one living in that vastness between the ocean and me.

A sudden thunderstorm swept in from the prairies and sent us scrambling off the ridge crest to find shelter, more from the lightning than from the rain. The brilliant bolts were striking below us in the valley. In the inimitable way of a child, I didn't feel afraid, because I trusted that my father had everything under control. When the rain stopped and the clouds lifted, we spotted a column of smoke coming from a tree that had been struck by lightning on the ridge running west of us about a mile away. Dad decided we should put out the fire. Thinking back, I was never sure how he planned to do this. In any event, by the time we were halfway along the ridge, the fire had burned itself out.

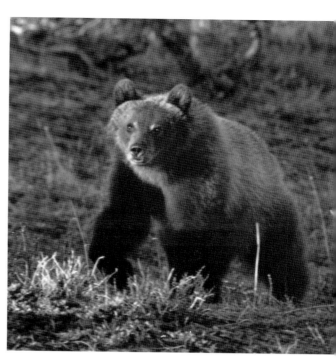

This young grizzly spent one summer near the Hawk's Nest.

I was riding close behind my father when Dad's horse stopped all of a sudden. A grizzly and two small cubs bounded up over the ledge, pausing right in front of us. The mother and one cub were dark, with a striking tinge of silver over their shoulders. The second cub was beyond belief — he was almost pure white, with dark eyes and black from his knees to his paws. The female and her dark cub loped away, but the white cub hesitated, curious about us. The sow suddenly came rushing back to collect her tardy offspring. That got Dad's attention! I can still sense his tenseness and that of the guests strung out behind us. I can still see the riders' wide-eyed faces and hear the rolling snorts of our horses. But, after reeling in her curious youngster, the mother bear turned and quickly vanished from view. There was great excitement around the campfire that night. My recollections are a bit fuzzy, but the stories were about how dangerous and unpredictable grizzlies are. Still, I came away from that experience with more curiosity about bears than fear.

My younger brother and sister, Gordon and Anne (there were five of us in all), had arrived on the scene, and we all thrived on this adventurous way of life. At the time I took it for granted, not realizing how special it was. We didn't even have to be in the mountains to see bears. Grandfather had inadvertently selected a site for his house in the middle of some prime bear habitat.

One summer a young grizzly took up residence near the house. He was drawn to our hill by a bumper crop of wild Saskatoon berries that weighed

down the tall bushes at the edge of the yard. When he came too close to the house, Mother would sic our collie dog, Kipper, on him, but the grizzly would soon return. Mother knew how to use firearms and would certainly not have been criticized for exercising that option in solving the "bear problem." But she ultimately handled the situation in her own remarkable way; for this and for many other reasons, I hold her in high esteem. She carefully observed the bear's behavior and, sympathizing with his need for the wild fruit, decided we could live with a grizzly as a close seasonal visitor.

Our faithful Scotch collie became very tolerant of the bear and would appear to ignore him as long as he wasn't near any of us. However, he would insist the bear keep a distance of about 50 yards (45 m) when we went to fish or pick berries ourselves. I remember feeling frustrated, wanting to observe the grizzly at closer range, but Kipper was ever mindful of his orders from Mother, and I couldn't do anything about it.

By the late 1950s the wilderness upon which we relied for our living in the outfitting business was being carved up by what Father called "the devil known as the bulldozer." Every year, more valleys were opened up with roads, and the natural resources of timber, coal and natural gas were exploited in a vain attempt to satisfy the appetite of an increasingly industrialized world.

When Grandfather Riggall died in 1959, our family knew we were reaching the end of an era. No compromise seemed possible for us; we were a family whose very life was roaming the mountains with a pack string of horses. We had become casualties of a changing world. What was most difficult to accept was not the loss of the outfitting business, but the loss of the wilderness which had become our home as well as the grizzly's habitat. Unlike the grizzly, however, we could adapt, as unpleasant as that prospect was to us. My father came to identify closely with the bear through this experience.

In search of other ways to make a living, Dad discovered he had skills not only as a writer, but also as a film producer, which opened up possibilities for yet another skill — using his wildlife films to lecture on his favorite topic of wilderness conservation as he toured the country. My brother Dick and I were eager to learn how to run the 16-mm movie camera. I was seventeen in 1958 and Dick was two years older. Here was a place we could put our skills as "mountain men" to work.

Our first contract was to work with Dad on a film about Rocky Mountain bighorn sheep. We were good trackers and hunters, but rolling a camera at close range required a more refined technique than either of us had ever

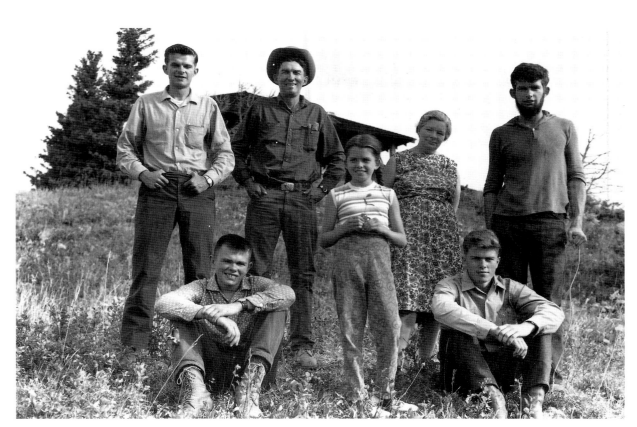

imagined. Although wild sheep are notoriously flighty, we persevered and collected some great footage. We also learned valuable lessons about gaining the trust of our subjects in the wild, and how to work and move around among them without frightening them.

It was our next filming project that really captured my imagination though. Dad had for some time entertained the idea of making a film on grizzlies, but because he wanted to record the bear throughout its remaining range from Montana to Alaska, he had to find special funding. When a foundation in New York came to our aid, Dick and I could hardly believe our luck.

As a child I used to pore over an old map of the Yukon which was yellow with age. It was my favorite, not because of its detail, but the lack thereof. The large areas that were blank carried the words "unexplored territory." For years I had dreamed of exploring these parts of the north country, and now Dad, Dick and I were setting out to film grizzlies in the wilds of the Yukon and Alaska. By then the maps of these areas had been updated, but filming grizzlies was still uncharted territory, thanks in part to their reputation for aggressiveness and the obvious difficulties of working with them.

In 1961 I was twenty years old and completely addicted to adventure

The Russell family in 1967. Standing from left: Dick, my father Andy, Anne, my mother Kay and me; sitting from left: Gordon and John.

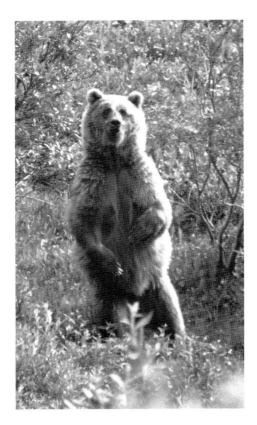

An Alaskan grizzly stands on its hind legs to get a better view of me.

and exploration. There was no precedent for filming grizzlies, much less anything on how to get the close shots we needed. We experimented with a large telephoto lens, but stopped using it because of a problem with clarity. We knew we were on our own, and that our judgments and decisions might mean life or death. The fact that we survived the next three years says something about our combined skills and decision-making abilities . . . not to mention the patience of grizzly bears.

We hauled cameras into whatever part of the wilderness we thought might be "Grizzly Country." I clearly remember a lot of grizzlies running away from us that first year, which, needless to say, made it difficult to record their behavior. We carried guns for self-protection at the beginning of our project, but by the second year had cast them aside, deciding it was better to trust our own wits and the bears' tolerance for interlopers. Guns are cumbersome, and it was a relief not to have to lug them around.

Initially, we had a devil of a time being secretive enough to film bears. The eyesight of grizzlies seemed better than they were given credit for, and we soon learned that their sense of smell is phenomenal. We considered building blinds, but we wanted the freedom of filming without such constraints. We were after natural situations where bears do what bears do in their habitat.

By 1962 we had discovered Mount McKinley (now called Denali) National Park in Alaska. There was no end of wildlife, including numerous bears. On one of the many days spent trying to figure out how to work with wild animals in ways that are acceptable to them, I watched wolves chase and kill caribou. The wolves seemed to be able to kill a caribou one minute and, shortly thereafter, trot by within a few yards of other herd members, with both wolf and caribou barely glancing at each other. I began to see that intent must be telegraphed somehow through "body language." I had previously observed a similar phenomenon while filming bighorn sheep. It was impossible to sneak up on the keen-eyed sheep, but by being open and casual in our approach we could actually walk among them. We had used the same technique successfully with Dall sheep, and with moose as well.

Because of the grizzly's reputation for seeking privacy, and sometimes demanding it, we were slow in adopting the casual approach with them. We

Looking for grizzly in southeastern British Columbia in 1964.

had stopped carrying guns by this time and were experimenting with ways to approach the bears. On several occasions we were charged in a very convincing fashion, indicating we had better respect their boundaries, which required a certain distance between them and us. In hindsight I wonder if our fear of them projected aggression and in fact precipitated the charges.

One day Dick experienced just that kind of close shave with violence. He was circumnavigating Toklat Mountain from our camp and had casually picked up the horn case of a small Dall ram that had died the previous winter. As Dick stepped on top of a sharp ridge, he found himself staring into the eyes of a large male grizzly which had been feeding on buffalo berries about 20 yards (18 m) away. The bear was in low bush as he started walking in a stiff-legged and aggressive manner toward Dick. The three of us had agreed that running away was to be avoided at all cost, reasoning that sudden flight might unduly excite a bear. Dick's nerve was about to be tested.

I met this friendly honey-colored grizzly in 1967 on a hike up the Toklat River in Alaska.

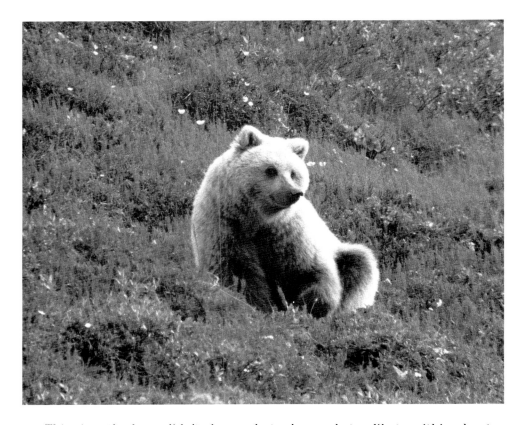

This time the bear didn't charge, but advanced steadily to within about 10 feet (3 m). Skilled from years of bluffing in poker, Dick instinctively raised the horn case above his head and made a motion indicating that he might club him if the bear came any nearer. The grizzly began to slowly retreat by stepping away in a sideways motion, occasionally facing Dick and chopping his jaws. Later, still shaking in his boots, Dick said he thought he detected fear in the grizzly. It appeared as though the bear wanted to flee but was afraid of turning his back on Dick. Finally, when the bear had put enough distance between the intruder and himself to feel secure, he began to run, splashing across the river and disappearing over another mountain ridge 3 miles (5 km) distant. Dick's accidental invasion of a grizzly's personal space had been interpreted as an aggressive act, and both parties had felt equally threatened. Fortunately for Dick, the bear chose to make a discreet retreat, obviously as glad to get away from the encounter as Dick was to see him go.

Dad, Dick and I probably worked with more than three hundred grizzlies in those three years of filming *Grizzly Country.* I see now how far ahead my father was in his thinking about the grizzly, and what a positive influence he had on how other people perceived this magnificent animal. We stood our ground in many full-blown charges and were not harmed, but when I

This large grizzly photographed along the Toklat River was cooling himself by lying on his back in wet sand and gravel.

looked back later at the incredible times the three of us had had, I realized that somehow I had not learned enough about bears. Perhaps, because it was more important to find my own place in life at that age, I was unable to see the complete picture of how my life was interwoven with that of the bears and other wild things. Undoubtedly, the seeds of understanding were sown in those early experiences, but at that time I was having too much fun to be serious about anything.

In 1967, I returned to Alaska to spend the summer, this time alone, carrying only my still camera to photograph and learn more about the grizzlies. It was to be an idyllic few months. Never before had I felt so much a part of the land, or so in tune with it. One day, as I neared the end of my two-month stay, I had a pivotal experience with a grizzly, an experience that suggested a different approach to getting along with bears.

A few days before I was to head south, I was privileged to find a grizzly that appeared to enjoy my company rather than be offended by it. I was on a long hike up the Toklat River to where it spills out of the toe of a glacier. From there, the valley gradually fills with ice and snow, until at its head it joins the white world of the Alaska range, where the highest mountain in North America, Mt. McKinley, towers above its surroundings. Around noon I spotted a light honey-colored bear grazing along a ridge. Because she

seemed to be working her way toward me, I didn't believe she was aware of my presence. Just to be sure, I stood up and shuffled around so that she would be sure to see me. Much to my surprise, she showed no alarm but instead sat down to watch what I was doing. After a few minutes, she continued to graze her way toward me. I perceived a gentleness and curiosity I had not seen before in a bear. I took several photographs of her at about 8 yards (7 m) and was with her for about an hour, reveling in the delight of shared trust between a grizzly and myself. It was exhilarating! I found her again two days later, in light too low to photograph. She came to within 10 feet (3 m) and lay down. I felt she had given me a gift — I was not afraid of a grizzly, for the first time.

The home ranch outside Waterton Lakes National Park was the glue that kept the family together, as we were often scattered all over the world. In 1970, my first wife, Margaret, and I were in New Zealand when we got wind that Dad was threatening to sell the land as none of us seemed interested in making a living from it. Around that time some close friends of the family, Belton and Genie Copp (her grandfather had been one of my grandfather's clients from the beginning), bought a beautiful piece of land next to our ranch. I became a managing partner for the Copps, bought six quarter sections from Dad and ran the combined 3,500 acres (1400 ha) of grizzly country as one large cattle operation.

I was determined to ranch in some kind of harmony with the wild animals that had occupied the land for thousands of years. There was a larger concentration of moose on the ranch than exist even today in Waterton Park. A herd of about three hundred elk wandered back and forth between the two ranches and the park. There were also many white-tailed and mule deer, along with coyotes, cougar, lynx, bobcats and the occasional wolf and wolverine, not to mention both black and grizzly bears. This mix of wildlife remains on the ranch today.

I found myself in the middle of an industry which during the previous 150 years had been responsible for the deaths of more bears, particularly grizzly, than any other group. Ranching is a wonderful way of life for someone who enjoys being outside while making a living. There can be times, though, when the cards seem to be stacked against the profit side of the ledger, as the effects of one more catastrophe reduce the number of animals that will make it to market. It is not difficult to see how cattle owners become "paranoid" about grizzlies. However, I was determined to give the bears the benefit of the doubt, and take my chances.

Tales of cattle losses attributed to bears were abundant and some were true. Cal Wellman, my closest neighbor, lost five calves in three days to a

black bear. Another neighbor lost yearlings to grizzly bears several years in a row. Sometimes I almost felt guilty because, during my eighteen years of ranching, I didn't lose a single cow or calf to a grizzly, and I ran up to three hundred cows. Upon revealing this to a neighboring rancher, he said that I would probably try to make out that a cow of mine had died of heart failure just as a bear was pulling it down.

One spring I was too late in discovering a cow that had fallen into a beaver dam. I kept an eye out for grizzlies while riding each day, knowing they would inevitably discover the carcass. I didn't mind donating one dead animal to the bears; the rich food source would be a great boost to a grizzly just emerging from hibernation. I reasoned that a bear would not necessarily develop a taste for the live animal. Sure enough, an enormous dark-colored grizzly hauled the cow out of the beaver dam. He had a beautiful silver slash of hair extending up his side and curving in behind his forelegs. He claimed the carcass, cleaned it up over the course of four or five days and chose to stay on the ranch for the summer. Although I rarely saw him, his huge tracks announced his presence. I called him Old Ephraim, after a famous stock-killing grizzly in Utah. (The name was later applied to the grizzly bear as a species over much of the western United States.)

On an early September evening that same year, my horse and I were enjoying the positive side of ranching — a quiet ride across the land. We were about to break into a clearing where approximately 160 cows and calves were lolling about in a classic picture of pastoral peacefulness. Over the top of some low aspen I spotted Old Ephraim approaching the clearing from the far end. On his current course, he would end up in the middle of the cows. I checked my horse and hid behind some trees, hoping the wind wouldn't give us away. The big bear and the cows appeared to be accustomed to one another. The grizzly seemed to make a deliberate attempt to be courteous as he selected his travel route through the resting cattle. To my amazement, virtually all the cows and their calves remained lying down, even when the bear passed by within 10 feet (3 m) of them! Only two stood up, as if to step graciously out of his way as he slowly passed. Finally, upon reaching the barbed wire fence at the end of the clearing, the 600- to 700-pound (270–320 kg) grizzly carefully put a paw on the bottom strand, pushing it to the ground, and elegantly stepped through. In two steps he vanished.

For a moment I sat on my horse dumbfounded. I then decided to follow the same route the bear had to see if our passage would cause any disturbance. When at least twelve cows jumped to their feet as we passed

through, I laughed out loud. I handle my cattle with as little disturbance as possible and yet I was causing more immediate concern than Old Ephraim had. Then and there I vowed to never again let myths of bear behavior dictate my thinking. In the future I would rely on firsthand experimenting and observing.

Not all of my experiences with bears have been so peaceful, but I can think of only a couple that were life-threatening and both happened within a year of each other. The first was in the spring of 1983. The rule about not running from bears is a good one, but there are always exceptions to even the best of rules. On this occasion a mauling would likely have been unavoidable if I hadn't run.

I was up on a mountain in Waterton Park, overlooking the ranch, with my good friend Beth. We were hiking along an alpine ridge at the end of a fine June day when we came across extremely fresh grizzly diggings. The finger-sized *Hedysarum* roots had been skillfully removed from the loose rocks and soil in which this legume grows. Not wanting to hike into the sun, we looped back along a spur ridge, which gave us a grand view of the colorful mountainside, just as the low sun seemed to light it from below. Our descent was temporarily halted at the top of a limestone ledge. It seemed a good spot to take a short break, so we sat down to look for the grizzly.

Almost immediately, a boulder came rolling out from behind some scrub fir trees, signaling the location of the bear. I estimated that it was about 150 yards (140 m) away, still digging out roots. A very pretty grizzly soon walked into view. My old Nikon camera was not known for its quiet shutter and, not surprisingly, even at that distance the bear heard it click. Without hesitation she started down over the red ledges toward our perch. Still snapping away and not particularly alarmed, I stood up and spoke to her to make certain that she knew what we were. This had no effect in slowing down her steady approach. At about 35 yards (32 m), she turned sideways and lowered her head, while proceeding to advance in a peculiar crossover stride.

Now I was worried! This particular bear, a female I believed, was not behaving in an expected way, especially when no cubs were present and we had not surprised her at close range. I kept talking to her, hoping she would stop, but she didn't. She had now reduced the distance between us to about 40 feet (12 m). Suddenly, to my horror, a large chunk of weathered root came flying over my shoulder, arching toward the bear. Beth, who had seen only a few grizzlies before, had decided to take the situation into her own hands. The root landed behind the animal, causing her to stop and

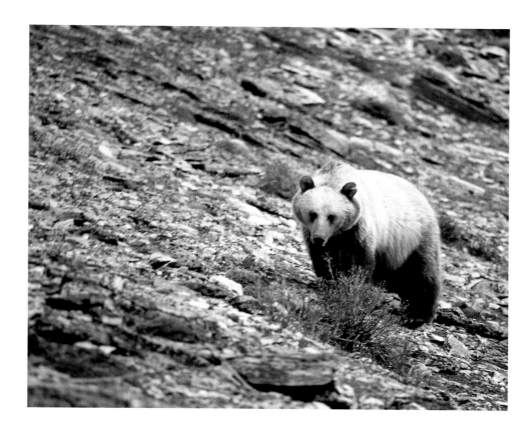

The female grizzly before Beth threw the root.

take a few steps back to sniff at it. I quickly suggested trying to find a way down over the ledge. No sooner were the words out of my mouth than Beth was in the air, dropping about 8 feet (2.5 m) onto a pile of boulders. I was certain she had broken her leg, but miraculously she landed safely and was off, down the slope as if there wasn't an obstacle underfoot.

I glanced back at the bear, which by now had broken into a run, heading directly toward me. The adrenaline rush I felt at that moment propelled me over the ledge, which only minutes earlier had seemed to pose quite an impasse. It was then that I noticed a half-eaten bighorn sheep directly below where we had been sitting. That was all I needed to know, and with huge leaps through the boulder field, I soon caught up to Beth. The grizzly came down to her carcass and watched us in our wild flight. I had a lot of difficulty convincing Beth that this had been a very unusual incident. It had clearly reinforced her view that grizzlies were terrifying and dangerous.

Interestingly, we had done two things that are generally forbidden for safe passage around grizzlies. The root-throwing was an aggressive action, which may have provoked a fight, and our running could have triggered a pursuit response in the grizzly. In this scenario, the first action had bought us time and the second, the necessary distance from her kill. My only injury was a slightly blackened eye, caused by the binoculars, hung around my

neck, pounding me in the face during one of my wild leaps.

I did have one experience with a bear that I wish had never occurred. Up to the time of this incident, I had been proud of never having been harmed by a grizzly or a black bear in my forty-two years living in bear country. This record was shattered one rainy evening in May 1984.

My son Anthony, who was a week away from his eleventh birthday, had joined me for a climb up Horseshoe Mountain, a couple of hours' walking distance from the ranch buildings. The glacier lilies were blooming in yellow profusion, and we were glad to see the prairie falcons back on the cliffs where my grandfather had first reported the species nesting some seventy years earlier. Our hike was cut short when it started to rain and, not being dressed for it, we were soon on our way home.

As is often the case in May, there was much evidence that bear were everywhere, including one of the largest black bear tracks I had ever seen. I was not worried because black bears had always been timid in our experience, quite content to mind their own business for the most part. Coming up over a small rise, somewhat in a hurry as I was now thoroughly soaked from the downpour, I spotted a dark brown female black bear with two yearling cubs in tow. They were a couple of hundred feet (60 m) down the slope, so I yelled to let them know we were in the area. I barely slowed down as they were off the trail and I expected them to bolt into the bush as black bears usually do. I looked back to see where Anthony was. He had wandered off the trail to pick up a small elk antler, oblivious to the deluge of water from overhead.

I glanced back at the bears and to my considerable surprise found the female running flat out toward me in a charge that, from my years of experience, was clearly not a bluff. A jolt of fear passed through me as I realized I had nothing — not even a knife — with which to defend myself. Bracing for the collision, I let out a yell that was supposed to indicate the presence of a strong adversary. It came out more like the sort of scream I would imagine making if I fell off a cliff.

The bear plowed into me in a leap with her front feet extended, catching me squarely in the chest. She wasn't that big a bear, but 175 pounds (80 kg) hurtling through the air sent me flying backwards. Then she was on top of me — all teeth and claws. I was fighting back, trying to push her off, but this was clearly the toughest fight I had ever been in and I was quickly losing. Suddenly I saw Anthony beside the bear, clubbing her on the head with the elk antler. How could he possibly have decided to join a fight as formidable as this when he could have fled to safety?

With the second or third blow, she turned on him. He backed away

quickly, narrowly escaping the snapping teeth and slashing claws. I tore into her from behind, kicking her with all my strength. She wheeled and was on me once more. Anthony was back at it with the club, but she tore it from his grasp as I grabbed her by the side of the neck, hauling her away from him. She bit into my wrist; I can vividly recall the excruciating pain as her teeth sunk into the joint. Losing the club didn't stop Anthony, however. He looked small but his movements were quick and distracting. Between the two of us we kept the bear off balance. The thought of my son getting hurt almost transformed me into a madman!

Not thinking too clearly, I yelled at Anthony to try to get away, but when he turned and ran, the bear followed. They headed uphill. I quickly realized I couldn't keep up, being somewhat hobbled by an old knee injury. I panicked, imagining the bear catching up to him with me far behind. By this time I was bellowing like a wounded bull and, with each bellow during my pursuit, she slowed to look back at me, giving Anthony precious seconds to stay ahead. They were 100 feet (30 m) ahead of me when Anthony made a dive to get under a barbed wire fence, but she grabbed him by the bum with her teeth. He twisted and kicked at her. By the time I arrived, my heart racing and gasping for air, the bear had a foot on his face. As I charged in, my snorting and blowing seemed to unnerve her for the first time and she left Anthony and headed away. She hesitated, seeming to be reconsidering. I had no more strength and told Anthony to be still. The bear, which I suspect had been harassed by a male bear we had seen earlier, finally disappeared.

I examined our wounds. Under Anthony's blood-soaked T-shirt was a long rip of flesh, but it didn't seem to be very deep. Along with another long gash in his forearm were numerous small cuts, including four neat tooth punctures in his rear end. Except for my wrist and deep bruises from the bear's pounding blows, my own wounds were superficial.

I couldn't stop asking Anthony why he had entered the fight. His humble reply was that he saw that I had nothing to defend myself with and he did! Curiously, the walk home was almost euphoric, in spite of the pain and trail of blood. Anthony was starting to realize the enormity of his deed. I was wondering what the hell I could say to this beloved child who had just saved my life.

At that time I had no inkling that eight years later he and I would be part of a very different kind of experience with bears.

The Quest

AFTER A TWENTY-YEAR HIATUS FROM professional film-making, I found myself setting out on another adventure. It was August 24, 1991. My friend Jeff Turner and I were on a fast-moving ferry that runs between Vancouver Island and Prince Rupert, British Columbia. We had started our journey the previous day from Jeff's home in Princeton, B.C., and were to disembark at Bella Bella, a native village about halfway along this route. But our true destination was a remote place on Princess Royal Island, east of the Queen Charlotte Islands. It would likely have been easier to reach Ellesmere Island in the high Arctic. By the time we arrived at our campsite, our 1,600 pounds (730 kg) of gear were showing signs of wear and tear from the seven times we had had to load and unload it on and off trucks, ferries and aircraft before reaching our final destination.

I went out onto the deck to watch the waves break over the front of the ferry. Although it was clear and relatively calm for Queen Charlotte Sound, there was enough wind from the northwest to create waves large enough to knock the ferry about. They were minimal compared to the size they reach in a storm. Here the cliffs of well-named Cape Caution are washed clean of all vegetation for hundreds of feet above the water line, evidence of the sea's fury that wins the respect of all who sail this coast.

It was exciting to be back in this part of the country. I had not been on the central B.C. coast since 1961, when Dad and I filmed coastal grizzly bears in the vicinity of Rivers Inlet. I had bittersweet memories of Owikeno Lake at the head of the Rivers Inlet area, where we had spent a month in a wilderness teeming with salmon and bears. Since then the whole area had been clear-cut, the inevitable fate of so much of the coastal rainforest.

Jeff and I were going to Princess Royal Island to search out the rare

As the rain stops, ribbons of mist wrap Princess Royal Island.

The soft green world of the West Coast's temperate rainforest.

Bunchberry grows on a rainforest log.

Kermode *(Ursus americanus kermodei)* or white bear about which little was known. This rare color variation of the black bear *(U. americanus)* was named in honor of Francis Kermode, a former director of the Royal British Columbia Museum, by American naturalist William Hornaday. The Kermode is the product of a double recessive gene. Princess Royal Island is known to have a relatively high concentration of black bears carrying this gene for white or cream-colored hair. Of the approximately 130 black bears on the island, nine to twenty are white. The island's isolation helps to concentrate this characteristic.

Jeff and Sue Turner were quickly becoming known as Canada's leading producers of quality nature films. Two years earlier they had hired me for my knowledge of and ability to work around bears. At that time they were shooting a film on grizzly bears for the Canadian Broadcasting Corporation program "The Nature of Things." The Turners had decided their next effort might be a film on the white bears of Princess Royal Island, but they knew it wouldn't be a simple shoot. Although the whereabouts of the white bears was known, there wasn't an instruction manual on how to find them. Thirty years earlier, I had heard anecdotal accounts of the Kermode bear for the first time. Not much had changed in the interim; any information about the bear was still somewhat superficial. Fishermen, loggers and others had reported occasional sightings, but that was all.

The Turners had first visited Princess Royal in 1990 with Wayne McCrory and Tom Ellison on Tom's boat, the *Ocean Light*. Wayne and Tom had spent the last ten years drawing public attention to areas, such as Princess Royal, that are unique to British Columbia. They believe that, if enough people learn about the natural history of this magnificent coast, they will come to value it for itself. Although Tom also runs commercial eco-tours, he often donates the use of his beautiful sailboat for reconnaissance trips. Wayne was along to look at the possibility of establishing a sanctuary for what he calls the "spirit bear." Although black bears and wolves were frequently spotted, the four got only a glimpse of a white bear. Despite this, Sue had returned home excited about the potential for a film. This optimism was largely generated by a chance meeting with someone on the island under rather humorous circumstances.

Jeff and Sue had spent a wonderful afternoon watching a family of wolves after a hike up Salal Creek. It was a hot September day and Sue had felt an urge to go skinny dipping in one of the beautiful, clear pools of the stream. Sue is a bashful person, but Jeff persuaded her that

there was zero chance of her privacy being disturbed. Tom and Wayne were hiking in another creek 15 miles (24 km) away. As fate would have it, of course, no sooner had Sue taken off her clothes and plunged into the water, than Doug Stewart walked around the bend in the creek. An observer would have had difficulty determining who was the more surprised. Doug is the B.C. Fisheries officer for a large portion of the coast, including most of Princess Royal Island. Part of his job is doing a census count of salmon spawning in the creeks. This count helps give the province's fishing industry some idea of the number of salmon that should be returning to spawn in two to four years. In his fourteen years of hiking up these creeks, Doug had encountered only two other people. He always traveled alone, except for his dog Bruno. After recovering from their embarrassment, the Turners realized they had run into a walking encyclopedia of regional information. Doug was very generous with his knowledge of the island and related story after story of white bear sightings, many of which he had photographed.

On our initial trip, Jeff and I knew that we had to collect some good

For more than a decade, one of Doug Stewart's many responsibilities has been to count the number of fish that spawn in the creeks of Princess Royal. This involves hiking and canoeing every productive stream several times a season.

footage of these elusive white bears. There were two good reasons for this urgency. First, without the footage, finding the necessary financial backing for the film would be impossible. Second, we had to prove to our own satisfaction that it was possible to work in the severe weather and incredibly rugged coastal terrain that make Princess Royal Island one of the most private places in the world. Sue had not joined us on this trip as she was eight months pregnant. Deciding that she would stay home was difficult for both Sue and Jeff because they had been partners in the field for a dozen years.

Finally, we were loading our heavy Zodiac inflatable boat and motor, camera equipment, tents, personal gear and food for two weeks into a Single Otter float plane for the final leg of our journey. It was late in the day by the time we took off from the Bella Bella harbor for Sillem Inlet, 60 miles (100 km) to the north. (At the risk of being perceived as somewhat hypocritical, I have decided that revealing the real names of places in this area could subject the vulnerable wildlife to unnecessary pressure. Therefore, the names I use here will not correspond with names on any map.)

We had timed our arrival to coincide with Doug Stewart's salmon survey at the end of the inlet. It was high tide; the shoreline was so rocky that we risked puncturing the delicate floats of our heavily loaded aircraft. Fortunately, Doug was moored in the inlet. We quickly unloaded our gear into a 20-foot (6 m) skiff, which he pulls behind the *Surfbird,* his 50-foot (15 m) aluminum boat. It was late in the afternoon and we also gratefully accepted an invitation to spend the night on board the larger boat. This would be the first of many times over the next three seasons that we would be rescued by Doug's hospitality and his superior knowledge of this part of the B.C. coast. He taught us how to survive the fury of that storm-lashed island. For example, he suggested that we spend the entire next day setting up our camp in a way that would withstand one of the severe coastal storms, which could last for as long as ten days.

Even though the weather the next day looked benign, we followed Doug's advice. The place that we named Camp Creek is breathtakingly beautiful with giant spruce and red cedars growing among the huge boulders strewn along the coast. We were enveloped in drapes of moss and green foliage. Locating a level spot to pitch the tents was a difficult task. Our 10 by 12 foot (3 x 3.5 m) cook tent became a multi-split-level dwelling. The sleeping tent was on somewhat flatter ground, but the entire area looked like a dried-up swamp — a warning sign we should

Moss thrives in the moist coastal forest. It survives dry spells during the summer by absorbing moisture from the damp air at night.

have heeded. We were only a few feet above the high tide line and somewhat exposed to the inlet.

Nightfall found us with an established campsite, but the sky looked ominously dark and Doug wisely pulled up anchor to find a more protected spot. He cheerfully called out that we needed rain to allow the salmon to get up the creek, so the impending change in weather was good news. Easy for him to say, I thought. There were indeed

Wading up the creek demanded stamina and concentration.

Devil's club, which can reach 10 feet (3 m) in height, is very difficult to penetrate where it grows in dense patches. Its red berry clusters are a favorite food of bears.

thousands of salmon milling around the mouth of the creek, waiting for an opportunity to swim up and over the 200 yards (180 m) of granite boulders, now impassable in the low runoff. The creek flattened out immediately upstream from this obstacle course.

As if on cue, it began to rain before we returned to camp and intensified quickly. It sometimes feels as though I have spent half my life sleeping in tents, but this was to prove one of the wildest nights I had ever endured in one. We realized our mistake about the "dried-up swamp" when the tent floor began to take on the qualities of a waterbed. When Jeff and I climbed out to dig a trench around our sleeping quarters, the wind picked up the tent as if to move it out of our way. We caught it as it was being rolled up onto a dense stand of huckleberry bushes — sleeping bags and all. I had never before experienced such a torrent of rain, especially in total darkness.

We soon had another problem. The previously docile Camp Creek was fast becoming a raging river, roaring out the creek mouth into huge, standing waves as it met the teeth of the wind. We had rigged a long pulley system for the Zodiac, like a clothesline across the mouth of the creek, so that we could position it well off shore, free to go up and down with the tide. Directing the beam of his powerful flashlight into the gloom, Jeff watched with horror as a huge log came hurtling down

the river, almost snagging the rope tethering our boat. We would surely have lost the Zodiac if it had done so. Thoroughly drenched by the downpour, we hauled the boat into the rocky shore, removed the motor, and in two trips lugged both it and the boat into camp.

In the morning, we were more tired than when we had gone to bed! The wind finally let up, but the rain continued. The only way to travel inland was in the creek bed itself, the terrain along the creek being blocked by a horrible tangle of logs and devil's club, a giant thorny nightmare that can cause festering sores. Overnight the creek had risen 8 feet (2.5 m), confining us to the lower 200 yards (180 m) of cascades.

On the second day of continuous rain, we discovered that black bears were catching salmon in the eddies along the shore of the lower part of the creek. The fish rested in these eddies in their struggle to swim up through the churning torrent. Finding some protection under an overhanging boulder, we spent many hours watching the bears catch fish, all the while hoping that a white bear would make an appearance. No matter how spectacular, black bear footage would not lend itself to a film on white bears. Our location was ideal, with the large number of fish and opportunities for bears to catch them. I guessed that if a white bear was in the area, it would eventually show up.

By the fourth morning the sky was looking brighter, even though rain continued to fall. Jeff and I walked down to the short stretch of sandy beach at low tide and noticed a black bear grazing on some intertidal grasses. It was drifting in and out of sight. We left the beach to make breakfast, assuming that this was one of the many black bears that we had been watching during the past few days. I should have been wiser. A crusty pilot friend of mine had once told me: "An assumption is the basis of a screw-up." You don't have to be a pilot to know the wisdom of those words. An hour later, leaving our cameras behind, we nonchalantly returned to the beach. We saw the same bear disappearing into the forest, trailed by two cubs — one of which was white! But even though I was angry with myself for missing a terrific photo opportunity, just seeing the tiny white bear lifted my spirits.

Lolling about waiting for bears to appear has its limitations in terms of mental stimulation. Jeff and I devised a way to set up a Scrabble board under the overhanging rock of our spotting perch. Engaging in word-warfare while keeping a lookout for bears helped to pass the time. The only down side was the impact on my ego. I had introduced the game to Jeff but, day by day, he became increasingly

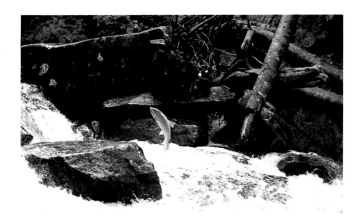
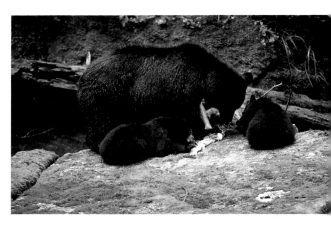

Watched by her two cubs, a female bear fishes at a boulder cascade. Later they share a meal.

better to the point that I could rarely win, even with my inventive spelling.

On day five, it rained heavily again. Still not able to travel upstream, we were exploring the convoluted world of boulders, moss and huge trees along the shore. Jeff peered into a long tunnel created by two large slabs of granite, one leaning on the other. He motioned excitedly for me to join him. A large white bear had been in the tunnel staring back out at him, but by the time I arrived, it had vanished. I quickly scrambled 20 feet (6 m) up over the rocks to look for the bear, but it was nowhere to be seen. We ran back to camp as fast as we could on the slippery terrain, snatched up our cameras and tripods, and hurried back to our sheltered spot in case the white bear decided to grace us with his presence again. I suffered through losing three more games of Scrabble before the bear appeared, this time on a log across the creek. By then, darkness was encroaching and we were rushing to set up our shots. Also, no sooner had the white bear begun fishing than Old Bent Ear, a black bear with whom we'd become well acquainted, showed up and chased the white bear into the bush.

The sixth morning dawned slightly clearer and the water began to recede. One black bear put in an appearance. We figured the others were probably fishing in the spawning grounds upstream, now that the water was low enough for them to do so. Gone were the hordes of milling chum salmon at the mouth of the creek, just as Doug had predicted. The bears had a big advantage in moving inland through the dense undergrowth. In contrast, our bipedal attempts proved hopeless. So much for evolution! Our first attempt at making our way up the

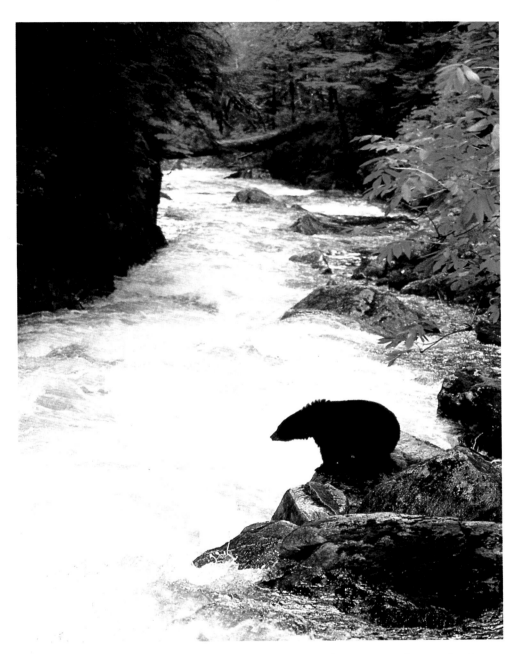

The fast water of the creek was almost as hazardous for the bears as it was for us. This bear was swept over a waterfall and narrowly escaped death.

creek was equally incompetent; it merely resulted in our getting soaked to the skin. We should have stayed in camp to take advantage of the brief patches of sunlight to dry out some of our clothing. Everything we owned was now wet, even our sleeping bags. Our cameras in their waterproof cases were all that had escaped the water.

The water level in the creek dropped a foot (30 cm) that night, so the following day we were able to struggle 2 miles (3 km) upstream. We soon found pieces of half-eaten fish — evidence of bears catching salmon — but Doug had told us of a better site another couple of miles

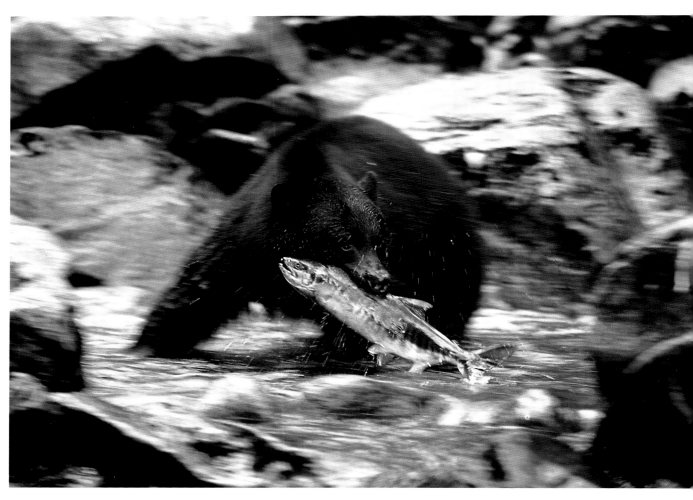

*The cascade near
our camp was
one of the better
fishing spots.*

upstream where the creek forked near a lake. Pursuit of that goal
would mean putting Jeff's expensive camera at serious risk as we
lugged it and the rest of the gear through this dangerous country. My
load of tripod, film, lunch and other odds and ends weighed 50 pounds
(23 kg), while Jeff's load of camera and lenses weighed about 70
pounds (32 kg). We eventually decided that I should do an upstream
reconnaissance alone, traveling light.

I will never forget that journey. I found myself wishing mightily that I
had worn my running shoes as the water was continuously coming over
the tops of my hip waders anyway. The rocks were so slippery that I
lost count of the times I fell. At one point, I slipped off a log and fell
into a deep pool to swim briefly — even enviously, although the water
was cold — with the salmon, before pulling myself up the slippery
bank. Eventually I did reach the forks near the lake. I didn't have much
time, as it was late in the day and darkness was something I dreaded
for the return journey. I gave myself twenty minutes to rest and take in

this lovely place where I could see up both forks of the creek and downstream as well.

Within five minutes a black bear sauntered along and snapped up a salmon only 75 feet (23 m) away from where I sat. I talked to him a bit but he paid me little heed, having better things to do. Before he finished his meal, a gorgeous white bear, its coat glistening, appeared on top of the log jam 50 yards (45 m) downstream and picked its way toward me. I judged it to be a female of about four years of age. It was my first close look at one of the animals we had worked so hard to locate. As I watched the bear, I decided it had been well worth the misery and hardship, but I regretted that my partner wasn't there to share in the moment. The bear half-heartedly chased a few salmon. After glancing at me, she disappeared up the south fork. Needless to say, Jeff was ecstatic to hear my report, even if disappointed that he had not been on hand to see the white bear. I decided that we needed the water level to recede another few inches in order to carry the cameras safely upstream.

It rained only lightly that night, and our wish for lower water came true. Nevertheless, the 4 miles (6 km) to the forks was an exercise in total concentration. Every step among the smooth, round boulders and over the water-polished logs tested our agility. The reward for all this hard work was two black bears at the forks. We waited in vain for a white bear before giving up and heading back to camp. We'd stayed too long and were now flirting with darkness with 2 miles (3 km) yet to go.

It had started to rain again and mist was hanging in the creek. All of a sudden an apparition appeared out of the mist, 8 feet (2.5 m) above the water level. The ghost was in the shape of a bear and shone almost as though it were suffused with an internal glow. As we stared at it, a black bear's silhouette appeared against the white ghost's flank. Were we hallucinating or simply losing our minds? Finally I realized that the bears were standing on a log protruding from the opposite bank but partially hidden by the mist. We were looking at the two cubs we had seen on the beach several days earlier. From below the log, I could hear splashing, and the shape of the mother black bear gradually took form, chasing a salmon through shallow water. She disappeared from view, likely going up the bank and into the woods with her prize. The ghost bear appeared to float through the mist before it too disappeared.

The following day we were approaching a level of exhaustion that caused us to question our ability to make a safe passage up the creek again. We were grubby beyond description. That night, the eighth of our

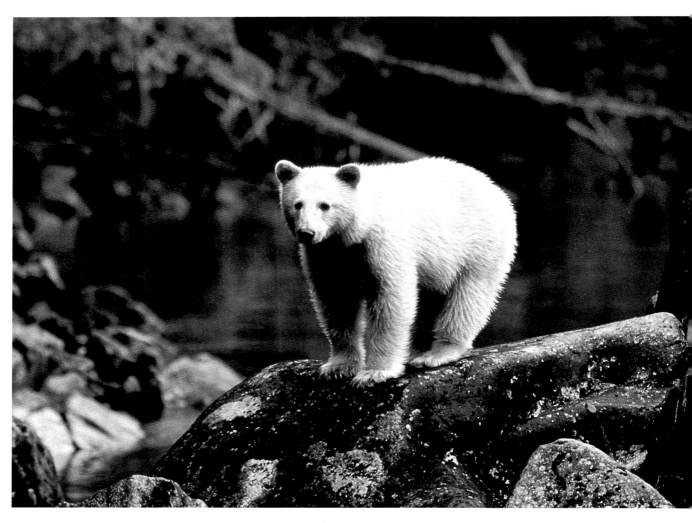

The Kermode bear is not an albino; it has a black nose and brown eyes.

stay, I started to lose track of what was happening. I think it rained again. I found myself starting to hope we wouldn't get the footage after all. Attainment of our goal would mean I'd be in for two six-month seasons of filming on that god-forsaken corner of the planet.

By the ninth morning, the stick we had placed in the creek as a water-level indicator showed only a 2-inch (5 cm) increase in the water level. We knew that if we had the stamina, we could make it to the forks one more time, but would we find a white bear? My pack seemed twice as heavy as usual and its straps felt like they were carving deep grooves into my shoulders. Jeff didn't appear to be finding it as difficult, perhaps because he is twenty years my junior. We headed up the creek, reaching the forks four hours later.

Sitting astride a log, we had good visibility in all directions as we played gin rummy in the rain with plastic-coated cards. Jeff glanced downstream and suddenly his eyes got large. In one smooth movement,

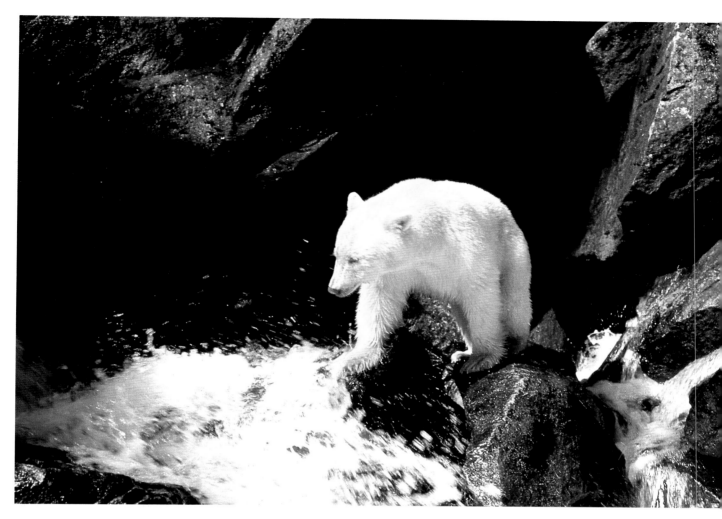

he was standing behind his camera, sliding the rainhood off the front of the lens. He had spotted a ruff of fur moving behind a log, but it had disappeared. Then we saw her. First we made out her legs and then the rest of her body, but she was walking upside down! In fact, what we were seeing was a white bear hidden behind one large log while walking on another — with only its mirror reflection visible to us.

As she had done the first time I saw her, the white bear worked her way upstream, performing as if on cue to our unwritten script. Curtains of spray were sent high into the air as she chased a big chum salmon through shallow water. She caught one 50 feet (15 m) from us, took it up on a log and, surrounded by her green world, proceeded to dine. Finishing only half of her fish, she slid down off the backside of the log and was gone. I knew Jeff rarely missed a shot. One look told me we "had it in the can" and were in business at last.

On the trip back to camp, we felt as though we were walking on the

As soon as a salmon appears, this bear will try to pin it down with its forelegs before grabbing the fish in its mouth.

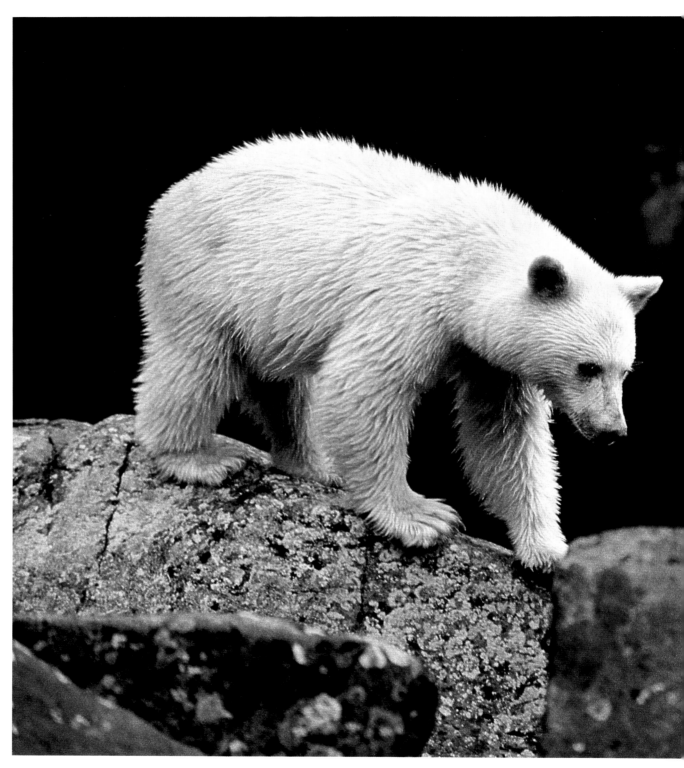

A white bear heads toward the creek to fish.

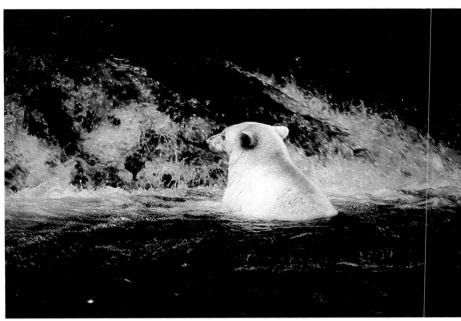

A male white bear waits patiently in the creek for a salmon to make a run up the falls or to bump into him in the foamy water.

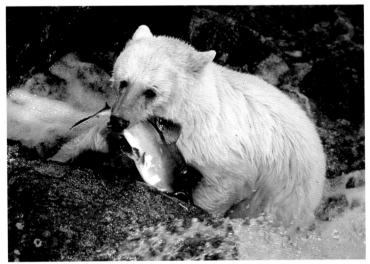

A bear clambers out of the creek to eat its meal of salmon.

water. I'd been weary and discouraged, but now I was filled with joy and looking forward to returning another year. At camp we feasted on spaghetti and discussed plans for our last day before the float plane would come to take us out. We decided to reassemble the Zodiac and head 10 miles (16 km) north to Salal Creek, where Jeff and Sue had watched the wolves the year before.

The morning was beautiful, calm and cool. Perhaps our luck had changed and, with one day left, we would find the wolves which were second only to the white bears in interest and rarity on this island. Skimming over the water, we spotted an otter scampering over some bright purple starfish. When we reached our destination, we calculated that we had until 6 P.M. before the arrival of the next high tide, which would make our launching easier.

We slogged up the first mile of the creek valley through dense foliage and emerged onto a long open stretch of sandy flats. It was a welcome change after the arduous journeys up Camp Creek. Many wolf tracks dotted the sand, and we soon found the tell-tale headless salmon lying around. Wolves eat salmon differently than do bears — they neatly cleave off and eat the head, leaving the body that we humans consider the choice part.

I was somewhat surprised to see grizzly bear tracks in the sand. I'd been told that grizzlies didn't live on the island. Upon reflection, I decided there really was no good reason why the big bears wouldn't be here — they're good swimmers and this was the kind of wilderness they would seek out if a living could be had there.

When it started to rain again, Jeff and I decided to find shelter and wait to see what would come along. Just as we were deciding to give up after five hours of waiting, an entire pack of wolves appeared, including the pups of that year. They trotted out of a side stream above us and moved down toward a riffle caused by spawning salmon. The dominant male rushed a fish and chased it to within 20 feet (6 m) of us before he spotted us crouched under the bank. His tail dropped, but he didn't run off. Jeff, who is pretty good at imitating wolf howls, began to howl. Soon the whole pack joined in — something I'd never before experienced in the wild and hope to experience again. It was a beautiful moment.

After Jeff shot some film of the wild canines, we headed back to the Zodiac and were surprised to see a large boat anchored in the bay. Doug Stewart had told us of an older couple from Seattle, Washington, who sailed these waters in a launch called the *Evening Star*. From his

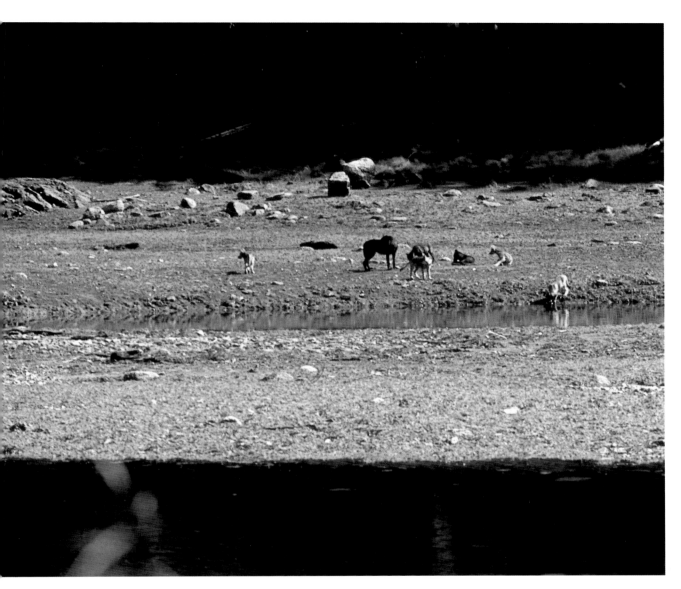

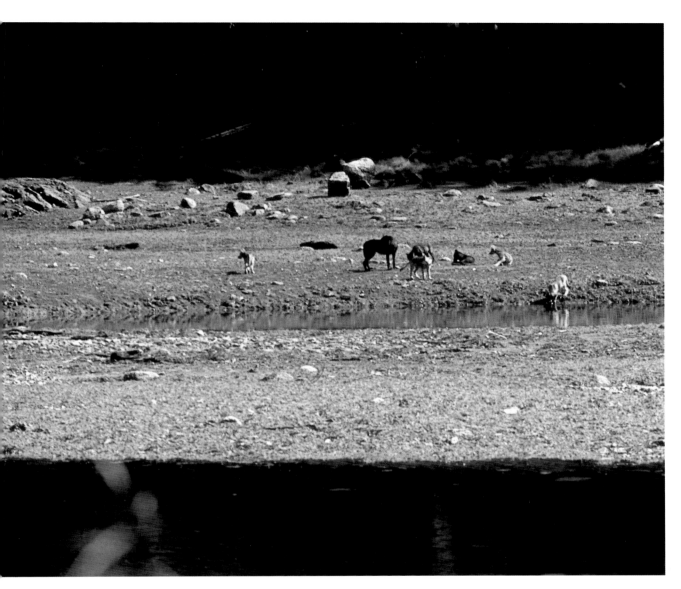

The wolf pack at Salal Creek.

description of the boat, we determined that this must indeed be Heine and Peggy Dole. Doug had also mentioned that with the exception of Jeff, Sue and me, they were the only people he had ever seen hiking on the island. We paddled out to their boat, not wanting to disturb the ambience of the evening with our motor. Doug had told them that we were somewhere in the vicinity, and they had been keeping an eye out for the Zodiac. There was no question now that our luck had changed — Peggy had supper ready for us!

Heine was eighty-one and Peg, thirteen years younger. They had forty-five years' worth of adventures up and down the B.C. coast to

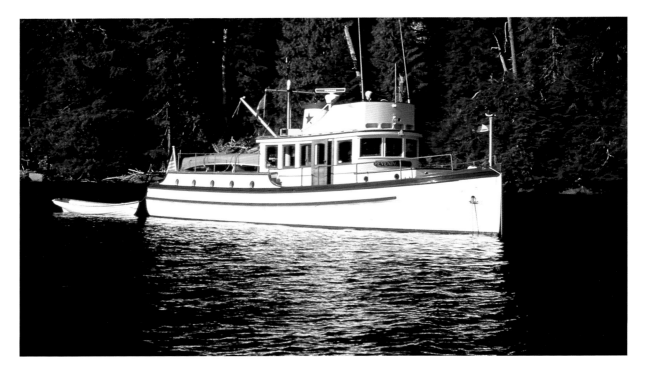

The Evening Star, *the Doles' beautifully maintained 47-foot (14 m) boat, was built by Heine in 1938.*

Heine Dole started exploring the coast of British Columbia in 1948. He and his wife Peggy began looking for the white bears of Princess Royal in 1962.

regale us with, and we wasted no time asking questions as we sat down to dine in one of the most exquisite settings I've ever experienced. Our accumulation of two weeks of scruffiness didn't seem to bother them. After we ate, Heine lifted the anchor and towed the Zodiac back to camp for us in the dark, navigating all the hazards with consummate skill.

Most sailors, years their junior, will not venture into the treacherous waters of this stretch of the B.C. coast. If they do summon up their courage to sally forth, the mere mention of an approaching front will send them scurrying to the nearest harbor. Yet here were Peggy and Heine, happily and skilfully sailing treacherous waters in September, the time of year that is notorious for turbulent weather. The

Evening Star and its skipper may have been aged, but their "oneness" appeared magical to me.

I asked them to explain what was so special about Princess Royal Island. Without hesitation, Peggy exclaimed, "No one has been here to spoil it yet!" I thought carefully about that. It wasn't just the solitude and unspoiled nature of this stretch of B.C. coast she was referring to; it was also the animals which had not yet learned to fear man.

That wonderful evening seemed the perfect way to conclude this segment of our adventure. I now knew we would be returning the following season. It was also clear to me that an added responsibility must accompany our filming effort. It was essential that when we were finished we must leave intact the pristine quality of the land and the innocence of the animals.

Eden

OUR HARD WORK SECURING THE WHITE bear footage led quickly to the necessary funding for the film. The British Broadcasting Corporation was interested in the prospect of creating a film about such an exotic animal, and we were equally happy to work with them since the BBC produces some of the best nature documentaries in the world.

Jeff, Sue and I put in a very busy winter preparing to spend the next two years on our new project. The Turners also had their hands full with their new baby girl, Chelsea, born in October. They optimistically assumed that it would be pretty much "life as usual" for them, with a small, minor adjustment tagged on. They were determined not to let child-rearing interfere with their work.

Because we were to spend two six-month periods on Princess Royal, it was a massive job just to compile the lists of necessities we would require to live comfortably in the wilderness. Having a very young child with us created logistical considerations that made the filming part of the project seem quite simple by comparison. Along with a special Ziess lens that cost many thousands of dollars, Jeff and Sue added a plastic wind-up movie camera for Chelsea so that she could get an early start in the film business.

Near the end of February, Doug Stewart offered to take us and a load of building materials on his boat as he traveled south to oversee a gooeyduck clam contract near Bella Bella. Jeff and I flew to Prince Rupert, bought all the lumber and plywood we needed for tent frames and an outhouse, and loaded it on the *Surfbird*. Three days later, as we were unloading two and a half tons of lumber at the Camp Creek site, I reflected once more on how difficult it would have been to proceed with this venture without Doug's generous help.

Jeff and I returned to Prince Rupert on the ferry from Bella Bella, then flew to Vancouver to spend a couple of days looking for a boat.

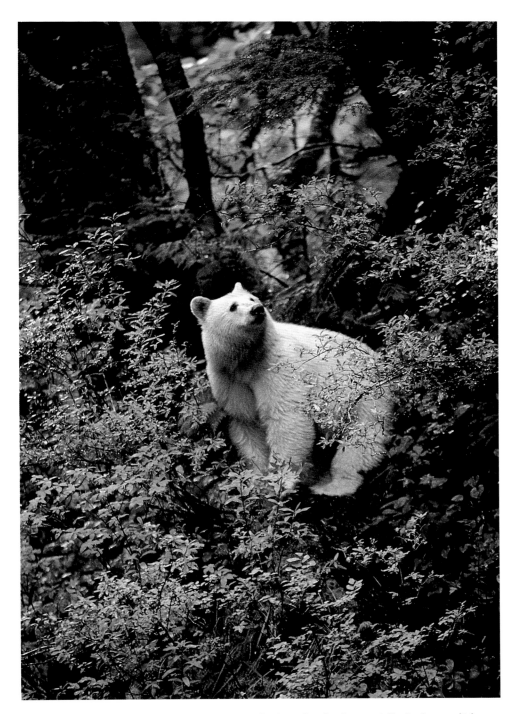

Although the Kermode bear looks like a misplaced polar bear at first glance, it is much smaller. The largest one we saw was approximately 400 pounds (180 kg).

Much thought had to go into our choice because it would be our only link with the outside world. Heine had warned us that our campsite was in a radio shadow and that we would have to go out into the main

Sue, Chelsea and Jeff Turner with the Sea Hound.

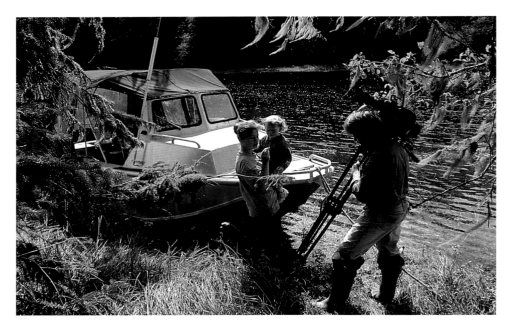

inlet with the boat to be able to call into the West Coast communication system. Our camp was located 50 miles (80 km) from the nearest settlement, the native village of Klemtu, so we needed a craft that could cover the long distances quickly and economically. It would also need to be seaworthy enough to handle the rough seas that could blow up in minutes, something we'd already learned during our reconnaissance trip the previous fall.

After much searching, we found the *Sea Hound*. It was a jet boat, which meant we didn't have to worry about damaging a propeller on the rocky shores. Jet boats use a powerful pump that sucks water in through a grate in the hull and blasts it out behind, creating propulsion from the force of the ejected column of water.

By the first of April, we were in Kitimat with the rest of our materials, equipment and provisions, which we soon moved to camp with a gillnetter we'd hired. A gillnetter is a fishing boat capable of carrying what would have taken eight or ten trips in the *Sea Hound*. En route to the island, we chugged through 170 miles (275 km) of uninhabited narrow passages. We passed by the abandoned herring-oil reduction plant at Buttedale, where as many as four hundred people had lived and worked from 1890 to 1967. Now we were going to be the only residents of the island for a good portion of the next two years.

We soon noted that winter had not yet given up its grip on our wild coastal island. The weather reminded us of what we'd encountered the fall before, only now it was much colder. If we were going to get our

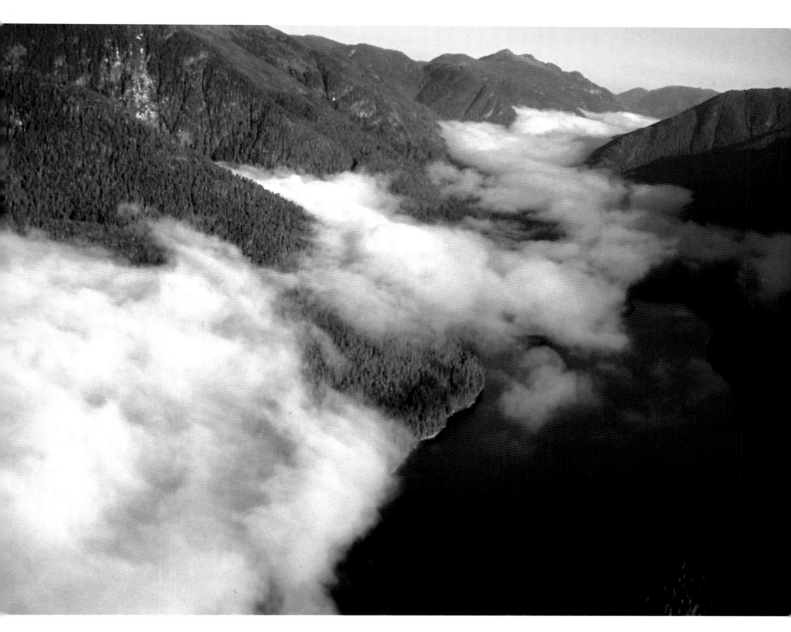

camp built, we'd have to get used to working in rain that was falling as snow only a thousand feet (300 m) higher on the slopes. Our challenge was to build a place where Sue and the baby would be comfortable when they arrived in late April. Because Chelsea would spend so much of her early life here, we began calling our enclave Camp Chelsea.

With some careful engineering, we brought water to camp by harnessing a spring that flowed from deep among the boulders above our campsite. The addition of propane to the gravity water system gave us hot and cold water, which lent our home a touch of luxury. Jeff and I were quite proud of our handiwork, which included a hot shower and

Our wilderness camp, hidden in this photograph under the clouds, was at the head of this inlet.

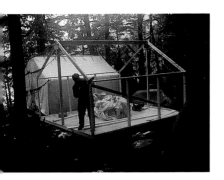

This photograph of one of the tent frames was taken in a lull between heavy rain showers.

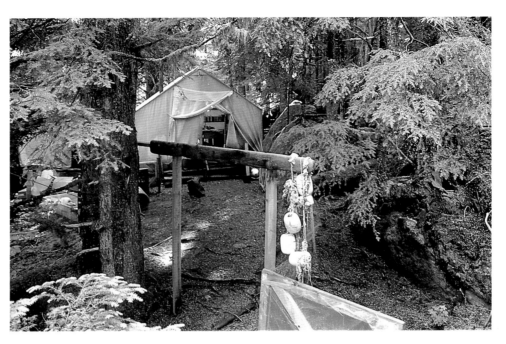

Camp Chelsea's entrance — a gate in the electric fence.

Jeff stands in the cook tent, which had the luxury of running water.

laundry facilities for the cotton diapers the Turners preferred to use for Chelsea.

We erected separate tents for cooking, storage and sleeping, including quarters for guests. Each large canvas tent had a rigid frame,

plywood floor and wood-burning stove. There was no shortage of wood. A 4-foot (1.2 m) diameter spruce tree, which had fallen near the camp, kept our stoves burning for the first month, and other fallen trees were not far off. Later we resorted to driftwood cedar logs that were dry and above high tide. We would chainsaw the logs into blocks and then carry two weeks' supply back to camp by boat.

My son Anthony has joined me in the Khutzeymateen Valley as well as on Princess Royal Island.
©Tom Ellison

Around the entire camp we built an electric fence to keep curious bears from sampling our food or garbage. The garbage would be taken to Klemtu each time we went for the mail, and the compost would be dumped far out at sea so as not to create smells around camp that would tempt the bears. As our elegant camp evolved, Jeff began to feel better about the conditions to which he was subjecting his little girl.

Our first visitor was my son Anthony. He was going to help the Turners during the month of May while I fulfilled an ongoing

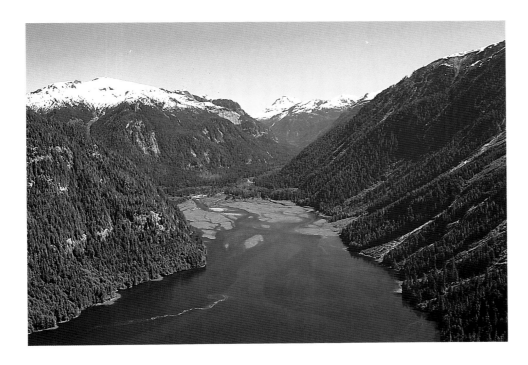

The Khutzeymateen Valley has been designated the first grizzly bear reserve in Canada.

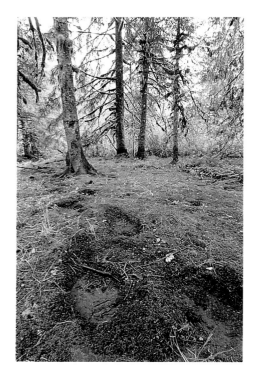

On this Khutzeymateen Valley bear trail, the bears step in the same footprints year after year.
© Brock May

commitment to be Tom Ellison's guide on his bear-viewing tours of the Khutzeymateen Valley, 200 miles (320 km) north of Princess Royal. The boat tours spanned three days each. As each new group arrived on a float plane, the previous group departed.

The Khutzeymateen Valley is an excellent habitat for both black and grizzly bears. It was in the Khutzeymateen that I had first been able to apply my forty-five years of experience with grizzly bears in a new and satisfying way.

The setting is overwhelming. A large sedge estuary is framed by a backdrop of glaciers, spectacular mountains and miles of crystal-clear rivers full of salmon, which wind through a mist-shrouded old-growth rainforest of towering Sitka spruce and western hemlock. The history of bear use of the area is written everywhere. Growth rings on scarred ritual rubbing trees record two hundred years of steady use. The trails leading into these trees have a sacred atmosphere about them. They are marked with large individual footprints pressed deep into the moss and spruce needles as the bears step in exactly the same places year after year. Some of these footprint depressions are more than a foot (30 cm) deep. The trees, and the trails leading to them, attract any bear that happens to be in the area, from young cubs to old males.

What struck me most about the valley was how friendly the bears were. They often seemed genuinely happy to see us, which took some getting used to. Two young males became favorites of my clients. They loved to wrestle, and were great fun to watch, but they caused me some anxious moments until I was able to relax and let them call some of the shots. I was astounded when I observed these same two bears learning to use people as shields to protect themselves from a larger, aggressive male. The male chased them out of the area whenever he saw them in the estuary. These intelligent young animals noticed one day that their nemesis was afraid of us. After that, the enterprising siblings began to take advantage of our presence by staying close to us when the big male was in the area. Sometimes they would even fall asleep near my group, obviously using us as security in order to get a good rest. This practice continued for several years until the two were mature enough not to be pushed around.

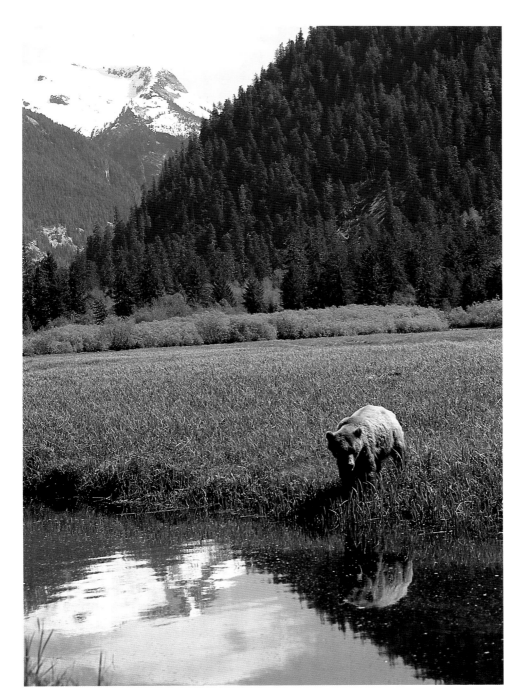

Against a magnificent backdrop of forested mountains, a grizzly bear makes its way to the water for a drink.

It was sobering to see how aggressive the Khutzeymateen bears were with each other, even though they displayed none of this behavior toward us. This was graphically demonstrated to us one evening as we drifted quietly with the tide in our inflatable boat, watching one of the grizzly brothers. By then he had grown into a hefty six-year-old. He swam across the narrow estuary channel not far in front of the boat. At about the same instant, we and the grizzly spotted a black bear as it

came out of the alders and wandered into the estuarine meadow to graze about 300 yards (270 m) away. After several of us grabbed the side of the channel bank to hold the boat still, we watched in awe as the scene unfolded.

Grizzly bears will prey on black bears whenever the opportunity arises, and this grizzly was no exception. He immediately began to stalk the black bear in a very menacing way. He crouched down and crawled along behind a log, using it as a shield to reach a depression, which would cut the distance between the two animals by half. Then he commenced another crouching sneak, looking more like a big cat in his hunting technique than a bear. I tried to put myself in the black bear's fur coat, and it made the hair stand up on the back of my neck. Here was a grizzly that had at no time displayed anything but respect and tolerance for us, but had now turned into the quintessential predator as he made plans to have his distant cousin for lunch!

At 50 yards (45 m) from his prey, the grizzly made a small mistake in picking his route to get behind a large boulder. The other bear saw him and instantly fled with the grizzly in hot pursuit. The black bear shot up the first big alder he came to, leaving his pursuer to make a couple of futile circles around its base before wandering off. Grizzlies cannot climb well because their front feet are better adapted for digging than climbing. Black bear claws, on the other hand, are retractable like those of a cat and can be used to grip the bark of a tree. Grizzlies are unable to retract their front claws and can climb trees only as a human does, by taking advantage of branches on which to get a purchase.

It still hurts to recall the fate of one female bear I got to know in the Khutzeymateen. We had spent many hours watching this beautiful grizzly and her cubs over two seasons. We usually saw her in a small estuary at the mouth of Mouse Creek, 4 miles (6 km) along the inlet. In May a species of intertidal sedge provides almost everything a bear needs for sustenance in the spring. At an early stage of its growth this sedge provides as much as 24 percent of the protein in a bear's diet, so the bears spend hours grazing, consuming as much as 50 to 100 pounds (23–45 kg) of this lush food each day.

We called this female "White" because of the color of the radio-tracking collar that had been put on her neck as part of a study to determine the effects clear-cut logging might have on the grizzlies of the valley. On occasion, White would seem to become concerned that her cubs might be getting bored while she was spending so much time

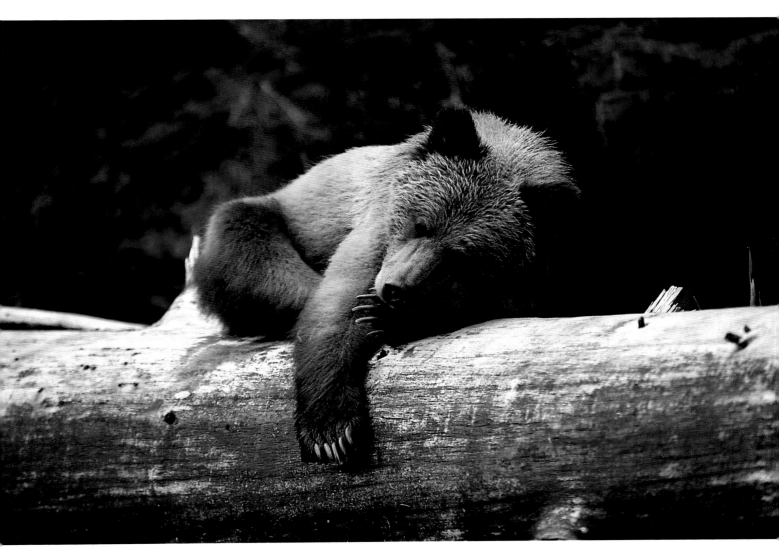

satisfying her nutritional needs. She appeared to initiate play activity to stimulate her offspring. She would push one of the cubs over or carefully bat at it until the cub got into the act. Then she would run from it to get a chase started. As that cub became a full participant in the game of tag, White would detour to where the second cub was sleeping. Kids being kids, the first cub would naturally divert some of its playfulness toward its sibling. Soon both cubs would be running and tumbling, leaving the mother to go back to feeding. The cubs sometimes carried on playing with each other in this fashion for half an hour or longer. It was as though the mother knew play was good for her cubs, to teach them co-ordination and strengthen their muscles.

One day we saw White and her cubs leave the area when a male grizzly appeared, traveling along the shoreline. A few days later, her

The orphaned grizzly bear was small for its three-and-a-half years when this picture was taken.

After its mother was killed by another grizzly, the orphan bear trusted people, but not other bears.

half-eaten body was discovered by biologist Grant MacHutchon after he noticed that the radio signal from the transmitter in the bear's collar had been in its "inactive mode" for two days. It is difficult to say, but she was probably killed and eaten by the male grizzly. Males are known to kill the young of their own species, so it's possible White died while protecting her cubs. The two young grizzlies were left to fend for themselves at only a year and a half. Only one of them survived that winter.

My brother Dick, who is now a biologist, conducted a grizzly bear study for Parks Canada in Jasper National Park, Alberta. He followed the lives of three cubs that had been orphaned at the age of six months. For three years he kept tabs on them. All three survived the first winter after returning to the maternal den. One — a male — disappeared a year after the death of the mother bear. Although they were smaller than they would normally have been, the other two, a male and a female, were still alive at the end of his study. The bears were four-and-a-half years old at that time. It was a remarkable demonstration of the toughness and resilience of these animals.

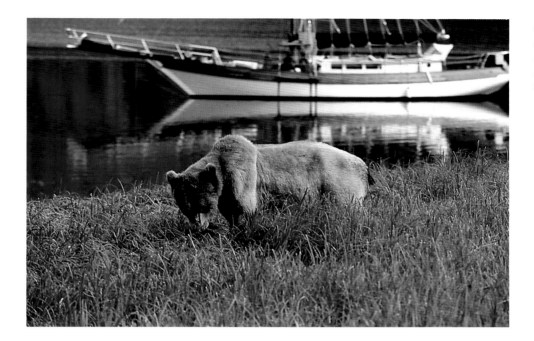

A grizzly bear grazes beside the Khutzeymateen Inlet with the Ocean Light in the background.

The Mouse Creek orphan displayed a wariness that was almost painful to watch. She continued to come to that same creek each spring and was constantly on the lookout for other bears. She could see or smell them coming from a great distance and would immediately leave, sometimes for days, until she felt it was safe to return to her preferred food source. However, her distrustfulness did not seem to extend to humans. I discovered the orphan once during an early morning cruise alone in the *Ocean Light*'s inflatable boat. Shutting off the motor, I slowly drifted ashore while talking in a steady voice

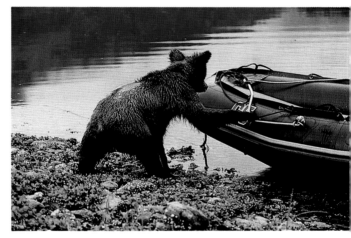

Bears are intensely curious animals. This one investigates the ropes on the Ocean Light's inflatable boat.

to her, mostly asking about what appeared to be a lonely life. The bear had crawled up on a log 200 feet (60 m) away and seemed to be listening intently. I had noticed for years that both domestic and wild animals can pick up many things from the tone and inflections of the human voice and, most importantly, can sense your interest in them. This may sound slightly wacky, but my cows taught me a great deal about this during my ranching days.

Climbing out of the boat, I sat on a rock at one end of a long strip of grass that grew along the beach. After watching and listening to me carefully for twenty minutes, the bear slid off the log and walked down to begin eating sedge at the far end of the green strip. I could see that her eyes seldom left me as she worked her way along the grass. There

were other grassy avenues that she could have fed on, but she had deliberately chosen the one that led to me. After another ten minutes, she had grazed up to the limits of the sedge nearest to me, and I could see she still wanted to come closer.

Since I had the luxury of being alone at this time and didn't have to be concerned about the safety of my guests, I decided that I would let her make the decisions. After all, if this was a place for bears, why did people have to make the rules regarding the distance between our two species? Ever since I had trusted bears with my cattle, I had wanted to explore this trust on a personal level as well.

What she did next made me want to chuckle out loud. The sedge that she had been eating ended where she now stood, 25 feet (8 m) away. A different species of dark-green wiry grass extended up to where I sat. She started munching on this grass as she worked her way closer, but I could see that she was really just pretending to eat and was spitting out every mouthful. Her eyes and ears were taking in everything, but her expression and body movements displayed the gentleness of a Newfoundland dog. She sat down only three or four steps from me, and I felt the same rush of emotion I had experienced twenty-five years earlier in my encounter with the Toklat River grizzly in Alaska.

Minutes later, I stood up and she stepped away a few feet. As I walked toward the boat, she ventured to the spot where I had sat, as if trying to learn more about me by running her keen nose over everything that I had touched. The orphan watched as I climbed into the boat and didn't flinch when I started the motor.

Although Tom had seen me leave the shore in the inflatable boat and had later pulled up anchor to motor in the same direction, he had not observed my encounter with the bear. I met everyone in the middle of the inlet for breakfast and was glad that I didn't have to explain anything right then. I needed to mull over what I had allowed to happen. I knew I was expected to set an example regarding human behavior around bears. What I'd done was very much contrary to conventional wisdom, yet I hadn't sensed any danger during the episode. I felt helpless and confused over the problem of how to improve the relationship between man and bear. I realized that a new understanding and approach were needed, but practically speaking, I had to assess whether others could safely experience what I had.

I wasn't breaking entirely new ground in my search for a better understanding. A century earlier, an American naturalist named Enos Mills spent many years of his life wandering the bear trails of the

Colorado Rockies and compiling remarkable records of grizzly habits and behavior. In those days the grizzly was being hunted mercilessly to eliminate it once and for all from cattle country. Mills had this to say about his favorite species in the preface of his book, *The Grizzly*, published in 1919:

> It would make exciting reading if a forty-year-old grizzly bear were to write his autobiography. Beginning with the stories from his mother of the long and exciting journey of his ancestors from far-off Asia and of her own struggle in bringing up her family, and then telling of his own adventurous life and his meetings with men and with other animals, he could give us a book of highly dramatic quality. Just what a wise old grizzly would say while philosophizing concerning the white race would certainly be of human interest. . . .
>
> . . . Relentlessly down through the years he was pursued. Dogs, guns, poison and traps have swept the majority of the grizzlies away. Their retreat was masterly and heroic, but the odds were overwhelming. In the midst of this terrible hunt the Yellowstone wild-life reservation was established. Instantly the grizzly understood, years before other big animals did, and in its protection at once came forth from hiding, eager to be friendly with man.

Mills's book remains, in my opinion, the best ever written about the grizzly, and I find it sad and discouraging that people in the scientific community have found ways to discredit him even to this day. In my mind the truth of his observations about Yellowstone Park grizzlies is evident among bears in the Khutzeymateen. Within five years of a moratorium on hunting in the Khutzeymateen, the bears there were also "eager to be friendly with man." I knew that I too would probably be discredited for my almost obsessive need to find a way to respond in kind to the bears there.

I had a great time rediscovering for myself what Mills had known a century ago. From the outset of my work in the valley, I slept on shore in a tent. I found it a welcome break. Although the quarters on the beautiful *Ocean Light* were a highlight for everyone, I found that by the end of the month I enjoyed a few hours of solitude each night in the rainforest.

I awakened early one morning to a familiar sound. In my youth on pack trips in the Rockies I would have identified it as the sound of a horse grazing close to my tent. As I became more alert, however, I realized there were no horses in the Khutzeymateen. Unzipping the

Killer whales were occasional visitors.

door of the tent carefully, I could see the feet, legs and muzzle of a large grizzly biting off mouthfuls of sedge behind a log. The bear was only 10 feet (3 m) from my nose! I could tell by his color and facial features that he was one of the "brothers," so I spoke to him. He must have already known I was there, because he paused for only about two bites of sedge before resuming his chomping. I found myself relaxing to the comforting sound that took me back to my childhood and horses. I drifted back to sleep but awakened again with a start. The bear had gone and I wondered if perhaps he had heard me snoring. I smiled at the thought because on occasion he had snored while sleeping near me. "Quid pro quo," I thought.

A few days before our bear-viewing tours for May 1992 were over, we got word that the B.C. government had decided to make the Khutzeymateen Valley the first grizzly bear sanctuary in Canada. It was a wonderful and fitting tribute to my friends Wayne McCrory and Erica Mallum, who had devoted seven years of their lives bringing the area to

the country's attention. The loggers may disagree, but I believe Wayne, Erica and other dedicated but responsible conservationists are true heroes. Most people do not realize how much society owes to these farsighted people who recognize the value of wilderness, not only as a refuge for besieged wildlife, but also for our own ultimate well-being as a species.

I arrived back at Camp Chelsea on June 4, 1992. Jeff had picked me up in the *Sea Hound* at Bella Bella and, taking advantage of calm weather, we took a shortcut to the camp through Higgins Pass. The hundred-mile (160 km) trip took three hours through stringers of fog and past several schools of dolphin. We had begun to feel at home as seafarers, more confident now of our ability to read the water well enough to avoid the countless rocks that could rip the bottom out of our high-speed boat.

Camp life had settled into a routine for Sue and the baby. Sue's mother Irene and sister Leanne alternately spent time with us, providing welcome help. Sue was doing the sound work for the film, which meant having to get away from camp. Anthony had departed to take up his summer job at Waterton Park before I arrived back at the island.

By now, there was no shortage of exotica to record. We even found the occasional pod of killer whales when they ventured into the inlet, often to play around our boat. They almost brushed against it with their huge black and white bodies. I had never experienced being around them before and marveled at their controlled power. Their gentleness toward humans was another enigma to me, especially since it was only recently that we had shown them any respect. Their large and complex brain must account for their understanding that perhaps we may become intelligent enough to appreciate them fully one day.

Actually, there is a connection between what we now understand of killer whales and the pathway to better understanding I'd like us to take in our relationship with bears. It is now well documented that killer whales are not dangerous to people. Attacks on divers and swimmers are virtually unknown, in spite of the fact that killer whales are well named for their ferocious hunting of sea lions and other marine animals, somewhat like the way grizzlies respond to opportunities to kill black bears. And yet both species, when given a chance, react to humans in a benign, even friendly way. Killer whales and bears are not something to automatically fear or loathe. They are far more our brothers than our enemies.

Jeff hikes up the shore of a Princess Royal creek.

The river otters on the island were more wary of us than any other animals living there.
© Adrian Dorst

Doug Stewart and his wife Carol told us of a thrilling experience they had had with a humpback whale. One of these enormous animals had come up under their skiff and gently lifted it out of the water. The whale had then set the boat down again, right side up. Their surprise "ride" had definitely added a new dimension to their whale-watching. Even the normally unflappable Doug talked excitedly about that particular experience.

The numerous river otters, which spend much of their time in the sea, were the most secretive of all the animals on the island and consequently the most difficult to work with. In contrast, Jeff discovered that the harbor seal pups would let him swim amongst them and, as long as he only put his head above water, the adults would allow him to swim with them as well.

As the weather softened into summer calmness, our life became easy in comparison to what we had experienced earlier. We began to explore the island and to familiarize ourselves with its many nooks and crannies. By traveling up the numerous creeks, we located every bear

fishing hole, knowledge that we hoped would aid us when the salmon returned. It was a wonderful excuse to explore, but we had to keep in mind that slipping and falling was the greatest danger in our work; every step had to be examined carefully for its potential to cripple. Our greatest challenge during the next two years was to ensure that we never took that fateful misstep.

By July the Turners were ready to take a break from the island, having been there for three months continuously. I stayed alone on the island for the three weeks they were gone, my only company being Sue's German shepherd dog, Tess. The poor dog pined for her mistress, which tended to get us both down!

I enjoyed the opportunity to explore on my own, but awareness of the consequences of getting hurt made me even more careful than usual. There was no one to look for me if I failed to show up at camp. I became interested in the ancient pictographs and rock carvings in Myer's Pass, the narrow channel between Princess Royal and Swindle islands, but could find no one at Klemtu who knew how to read them.

Eagles, ravens and whales all play significant roles in the native stories and legends that make up the history of the West Coast. The legend of how the white bear was created was of particular interest to us. It was told to me this way:

> At the beginning of time, so the legend goes, the whole world was white with ice and snow. Then the raven came from heaven and made the world green as it is now. But he also wanted to make something to remind himself of the beginning and its whiteness. So on this island, the one where people have never lived, he went among the bears, the black bears, and every tenth one he made white. That way he could look at them and remember the world as it was. And then the raven issued a decree: The white bears would live here forever in peace.

This was known as the Raven's Guarantee. Because of the raven's legendary commitment to the well-being of the island and its bears, I had been looking for an opportunity to meet one.

On occasion I had observed a pair of ravens on the beach in front of camp. Two days before the Turner family was due back, I began to vocalize with one of these birds, which was picking through seaweed and flotsam about 50 feet (15 m) from where I was replacing the spark plugs in our Zodiac's outboard motor. I started the exchange by mimicking his clucking. When I saw he was interested, I put down my

According to native legend, the raven decreed that the white bear should live in peace on Princess Royal Island.

© Mark Hobson

tools and, to amuse myself, began asking questions about the legend of the Guarantee. He responded by jumping up onto a rock that was part of an ancient fishing weir the natives had used to corral salmon as the tide receded. Such weirs are common at the heads of most inlets throughout the islands. This one looked as though it had not been used for several hundred years.

Perhaps I'd been alone too long, but it seemed as though my raven friend had been waiting for an opportunity to talk. He babbled away for several minutes. Ravens have a tremendous variety of vocalizations in their repertoire, and this bird's long dissertation in answer to my questions included some very strange hooting noises and guttural tongue rolls. After he had finished, I made a pact with him to take on some of his burden. I imagined that if he could speak my language, he might be telling me that if we were going to take from the island, we should find a way to give something back.

Our conversation went on for twenty minutes. If anyone had been listening, I'm sure they would have been convinced that it was time for me to take a break from the bush. The raven hadn't moved from his perch on the weir even though his mate was by now a fair distance away, paying little heed to our deal-making. I suddenly remembered that I had put spuds on to boil and hurried off to the cook tent to rescue them.

I was going to leave the island for a two-and-a-half week break once the Turners were back. At 6 on the morning I was to meet the plane at Klemtu, it was very foggy but I was confident that it would burn off. Even if it didn't, I had written down the compass headings that would get me the first 25 miles (40 km) out of the inlet. While eating breakfast, I mentioned to Tess that we were going to see Sue, Jeff and Chelsea. She became very rambunctious at this news and wouldn't let me sit around any longer, fog or no fog. The tide was out and I had bags of garbage, a propane tank and my personal gear to lug far out onto the beach. I planned to use the canoe to ferry Tess and my load to the *Sea Hound,* which was anchored in the cove.

As I was making my last trip between camp and boat, I heard a raven cluck at me from the top of a large boulder only 10 feet (3 m) from the trail. It was the bird I had talked with a couple of days before, and he seemed to want to pick up our conversation where we'd left off. I was surprised at how gentle he appeared to be. I had never before been this close to a wild raven. He was fluffing his feathers while softly doing his tongue roll. When I tried taking a couple of steps toward the rock, he stayed where he was, apparently not frightened by my walking up to him. Moving my wrist and fingers in a slow stroking manner, I reached carefully out to him as I softly talked about the hazards of boating and flying in the fog. The raven was quiet but had hunched his shoulders and was holding his head low. His wings were stretched out along the top of the rock, which was slightly higher than my head. In time I was able to touch the tips of the primary feathers of the wing that was extended toward me. I ran my fingers slowly up the leading edge of this wing and stroked the underside. At once both of us noticed Tess loping up the trail from the beach. She had become impatient with my diversion and was coming to see what was holding me up. The raven slipped into the air, circled in the mist and disappeared. I was angry with the dog until I discovered that she had been patient until the tide had advanced to the point of lapping against my duffel bag!

Starting up the *Sea Hound*'s motor, I was exhilarated by what had just happened with the raven and was ready to tackle the fog. After mentally preparing myself to put my trust in the compass, I reveled in the challenge of traveling blind. After forty minutes, the sun melted the fog away and it was clear the rest of the way into Klemtu. "It's a great day on the coast," I thought to myself.

▼▼▼▼▼▼▼▼▼▼▼▼▼▼▼▼▼▼▼▼▼▼▼▼

Spirits Meet

O N A U G U S T 1 7 , 1 9 9 2 , J O H N W A T E R F A L L ,
the pilot of a single-engine Beaver aircraft, finally loaded two
other passengers and me aboard, along with a huge pile of
mail, luggage and freight, and taxied out into the Bella Bella harbor.
Although the sky above us was clear, our final destination had been
fogged in and we had been held up for more than an hour. Apparently it
had now cleared enough at Klemtu for us to land. This was the last leg
of a long and complicated trip back to Camp Chelsea from my ranch in
Alberta, and I was anxious to see the Turners and hear news of the
white bears.

I had been out of touch with Jeff and Sue while I was on my break
and had no idea how things had gone in my absence. On arriving in
Bella Bella, I had asked whether the unusually hot, dry summer had
been broken by any rain recently. The dry weather had reduced the
runoff, making it impossible for salmon to enter the creeks on their
spawning run. Without rain, the bears were forced to stick to their
summer diet of berries and skunk cabbage. I was told that the village
had experienced rain showers four days earlier and that perhaps there
had been more farther up the coast. As we flew north, I looked down at
the streams of Roderick Island and saw that they were far from robust.

I finally decided it was useless to worry about the weather when the
day was so beautiful. Taking advantage of my seat next to the pilot, I
tried to picture how plate tectonics had worked to create this rugged
coastline. About 100 million years ago, the granitic rock forming
Princess Royal Island, together with the Wrangellia and Alexander
terranes displaced from lower latitudes, collided with what was then
the western reaches of the North American Plate to form the Coast
Mountains. The mountains were subsequently rent by faults and
fractures, and eroded by ice, to create the chain of islands now found
scattered like beads of a broken necklace from Vancouver, British

70

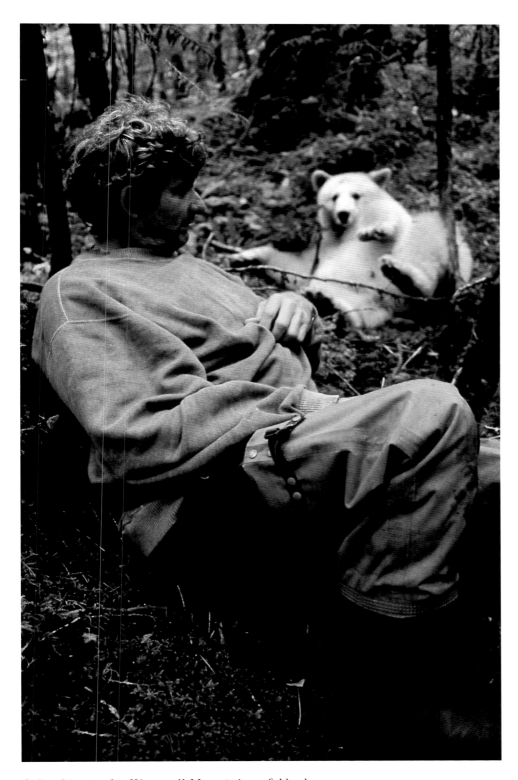

In my career as a wilderness guide, I had never before encountered bears with such trust in humans as I found on Princess Royal Island.
© Jeff Turner

Columbia, to the Wrangell Mountains of Alaska.

This faulting became evident as we gained altitude. Glaciation had carved out and shattered rock along the major fault lines, leaving deep

An alpine lake 2,700 feet (820 m) above Camp Chelsea.

cuts that run straight for many miles, their sheer granite sides plunging
far below sea level. But the landscape is not all ragged — the coastal
mountains end abruptly and a stretch of cedar-covered lowland extends
into most of the outer islands. The tallest hill on the island of
Aristazabal, for example, rises only about 600 feet (180 m) above sea
level. The south end of Princess Royal Island is also quite flat. My
musings on the land's patchwork-quilt makeup ended when I realized
we were nearing our destination. Picking small holes through the fog

banks that still piled up against the steep sides of Swindle Island, John banked his way down through the tunnels in the clouds, until Klemtu became visible. The pilot in me was full of admiration and envy of his skill.

As we taxied into the dock, I saw no sign of Jeff or the *Sea Hound*, though I was by now over an hour late myself. Shouldering my day-pack, I headed into Klemtu on the long boardwalk that curves gracefully into town. The locals claim with pride that at about half a mile (1 km) in length, it is the longest elevated boardwalk in the world. Built on pilings about 16 feet (5 m) above the high-tide line, with an extravagance that would likely not be possible anywhere else in the world, the boardwalk was constructed from hundreds of thousands of feet of lumber cut from the now abandoned sawmill at the edge of the village. After its construction, the residents discovered that the walk could also accommodate small trucks and cars, leaving only inches to spare on either side of the vehicles.

I was pleased to see Jeff at the gas dock when I returned from town. Questions tumbled out as I sought to catch up on events since my departure. Yes, they had seen a white bear, but had failed to film the elusive animal. The storm I had heard about had indeed reached Princess Royal Island and about 2 inches (5 cm) of rain had fallen. Coho salmon were finding their way into the creeks and, although the water level was dropping yet again, the bears were now catching salmon.

It was Heine and Peggy Dole who had spotted the white bear first. Months earlier, they had questioned the wisdom of our decision to try to film the white bears before the salmon came into the creeks. Doug Stewart had predicted an early salmon run of 20,000 fish by mid-July. It was now four months since our arrival and we were all feeling a bit sheepish. To add to our chagrin, the Doles had sailed to the island on the day that coincided with the first rain in months and, within minutes of their arrival, had spotted a white bear at the mouth of what we called Canyon Creek. They graciously pointed out that in some years they had not seen a white bear at all.

On the previous day, Jeff and Sue had gone to the spot where Heine and Peggy had seen the bear, a 25-mile (40 km) one-way boat ride from camp. They were rewarded at dusk by the sight of a white bear, eating barnacles as it strolled along the beach. Jeff had visited the mouth of the creek again on his way to Klemtu to pick me up, but this time there was no sign of the bear. He had been encouraged, however, to see

black bears feeding on coho salmon in the stream. In this part of the world, where there are black bears, a white bear is not far away.

Jeff had been delayed by engine trouble with the *Sea Hound*, which was experiencing a severe case of the hiccups. He had traced the problem to a water-contaminated fuel drum back at camp, but there was no quick solution. Consequently, his trip had been a long series of lurches, broken by episodes of removing and cleaning the fuel filter and sediment bowl. Although we borrowed a pump and drained the tank completely to rid it of the contaminated fuel before setting off from Klemtu, we were soon faced with the same engine trouble again. Somehow we had failed to get the water completely out of the system. Every 2 miles (3 km) or so we were forced to stop, and these stops became even more frequent when we ran into the rough water on the west end of Myer's Pass. It was late evening before we arrived at the bay near where the white bear had been last seen the previous evening.

I was thrilled to see Peggy and Heine and again have the pleasure of joining them on board the *Evening Star*. Most pleasure craft had long before returned south to beat the approaching storm season, but the Doles were confident of their seafaring skills and able to relax and cope with whatever came along. Once more I was struck by their apparent discovery of the secret of eternal youth. My favorite quote of Heine's is: "You grow old when you lose interest in things!" — something to keep in mind given that I would turn fifty-one within two days.

That day, no one had observed the white bear, but black bears had been seen catching salmon at the mouth of the creek. We stayed overnight on the *Evening Star* and enjoyed another memorable dinner. Our plan was to spend the next day waiting to see if the white bear would return. It seemed unlikely that he would stay away for long since he had been fishing in the area. From Peggy and Heine's description, I had surmised that the bear was young and might well have been intimidated by the older, more dominant black bears catching fish in the canyon.

This canyon is a particularly beautiful place. It starts at a tidal pool, which has a waterfall 7 feet (2 m) high cascading into it; 500 feet (150 m) beyond, more falls are tucked under a diagonally sloping wall cut into the granite along a fault. Because the overhang on one side of the canyon balances the face sloping away on the other side, much of the bottom of the gorge is protected from rain. It is dark most of the day, but at certain times, when the sun is shining, shafts of bright light penetrate this protected space. Nevertheless, this was clearly going to be a very

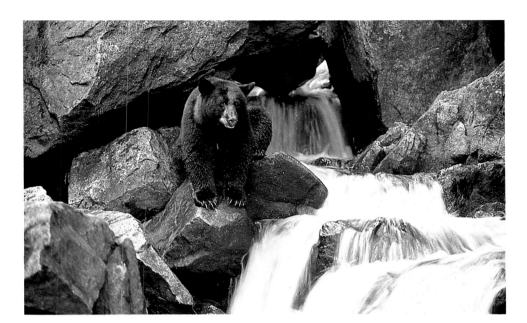

This female black bear was the boss of the canyon, but she was very gentle toward us.

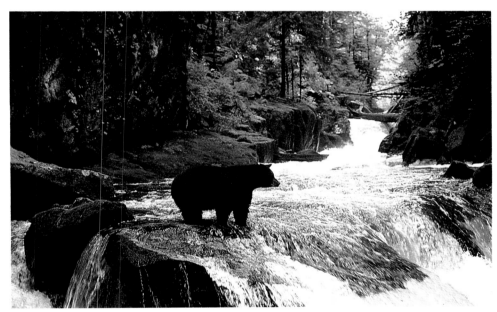

Its mossy banks made the creek look as though it had been carved in jade.

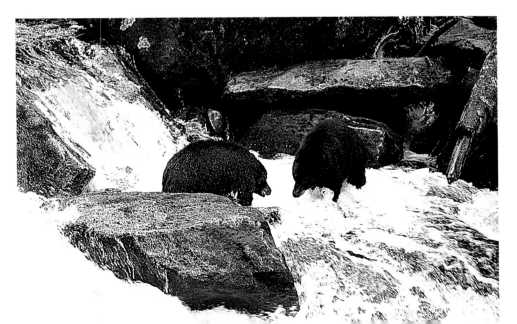

At the beginning of the salmon season, the bears display aggressive behavior as they compete for good fishing spots and get used to being close to one another.

difficult place to film anything, especially a black bear.

I spent some time monitoring the movements of the black bears in the vicinity of the second waterfall, and we finally selected a spot where Jeff could set up his camera with a clear view of the many nooks and crannies of the canyon. It was thrilling to observe how quickly the black bears accepted our presence as they went about their business of catching salmon in the rushing water. If we could find a white bear, the prospects of getting some exciting footage were excellent.

At the end of my first day back, I still hadn't seen a white bear. It wasn't wasted time, though. Five black bears fishing in the canyon provided us with an interesting opportunity to learn how we could film and get to know these animals. On the other hand, each of the next few days was more frustrating than the last. Not only were the white bears doing a vanishing act at Canyon Creek, but the *Sea Hound* was once again causing trouble. The 50-mile (80 km) round trip became even more of a challenge when we discovered that in spite of solving the water-in-the-gas problem, we were now suffering from "fuel starvation." Although I pride myself on being a good trouble-shooter, I couldn't figure out why the big V-8 engine wasn't getting enough fuel. The source of the problem had to be the fuel pump, but there were none of the usual signs and we had no apparatus to test it. By putting on a squeeze-ball hand pump, we were able to supplement the regular one enough to continue motoring; nevertheless, our boat continued to plague us with what felt like an endless parade of malfunctions including a ruined bilge pump, a flooded alternator and a short in the spark plug wires. At the end of the field season, we found out that all of our difficulties were linked to the water that had gotten into the gas.

One afternoon the sun swung around and sent its shafts of light into the dark world of the canyon. Jeff had his camera and tripod set directly in the waters of the creek to allow him to film the salmon as they leapt up the falls toward him. I was watching an old male black bear draped over a rock, basking in the sun. Beads of water were glistening like diamonds on his blue-black coat, still wet from the creek. As I drew Jeff's attention to the beauty of the scene, the bear looked over our heads at something and turned rapidly, bounding for the cover of the forest. We, of course, spun around too, with some concern as to what possibly could have frightened this large and otherwise aggressive-looking male.

There, coming down the crack in the overhanging wall, was a white bear. Although not large, he moved with great purpose. I will never

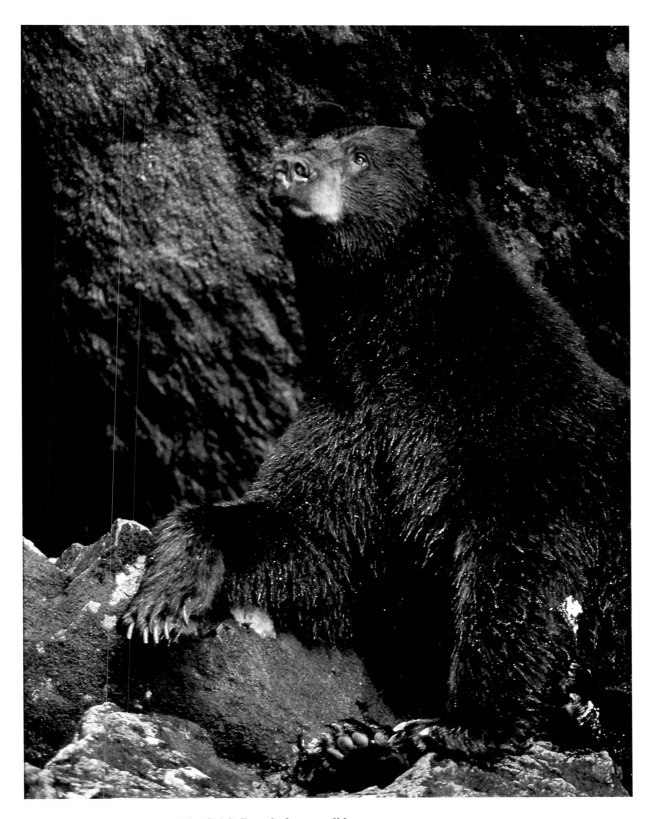

This old black bear spotted the Spirit Bear before we did.

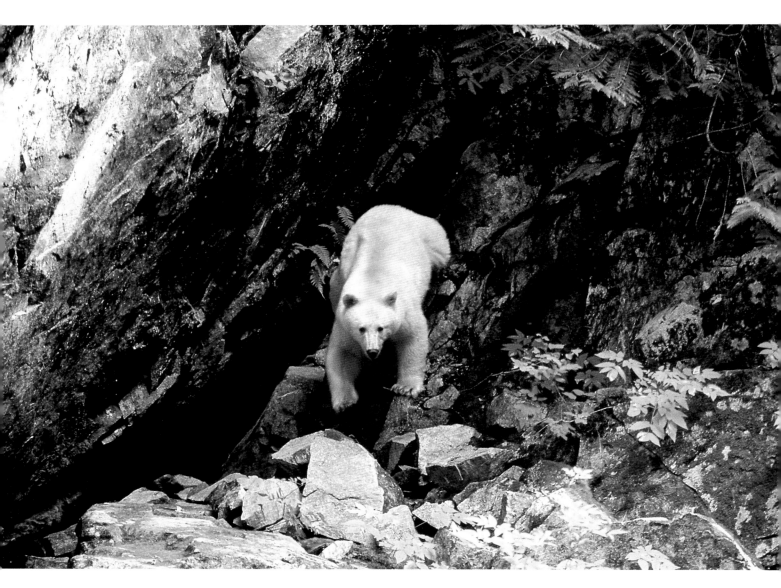

Our first encounter with the Spirit Bear was when he suddenly descended through a large crack in the overhanging wall.

forget what a thrill it was to catch that first sight of him. Conditions could not have been more perfect for filming, but what happened in the minutes that followed still makes me shake my head and laugh.

The white bear strode into the creek below us and moved swiftly upstream. Jeff was standing precariously in the fast-moving water. When he repositioned himself, the bear must have thought his moving feet were salmon. Before Jeff could roll any film, the animal had poked his head almost under the tripod to have a close look at the source of the movement underwater. To his credit, Jeff remained calm. He picked

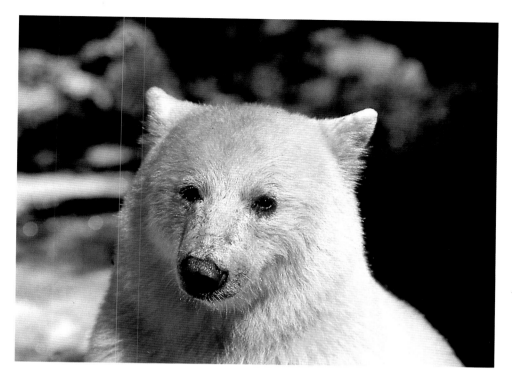

When we first met, the Spirit Bear ambled up to give me a quick examination before catching a fish and returning to the forest.

his feet up slowly and set them down, showing the bear that what had splashed was part of the photographer and not a salmon after all.

I ran out of slide film and headed downstream to my pack, which I had left on a flat rock. As I was digging my film out, the white bear scrambled down over the ledges in the stream toward me. I quickly lifted the back of my camera, but before I could change the film, he stood up on his hind legs and looked down into the camera. His nose was only inches from it! I could scarcely believe what I was experiencing. Here was a wild bear, of fearsome lore, examining me and my trappings as though I were a novelty, a cousin from the big city come to visit — an object of curiosity, but definitely not something to fear, or to eat for that matter.

I knew Jeff wasn't filming. "Bear-human interaction" was not in his script. While I was attempting to mount another lens onto my camera, the bear suddenly seized a large coho as it tried to propel itself over a ledge in the shallow water. With the fish flapping wildly in his mouth, he climbed quickly up through the diagonal crack in the hanging wall from which he had earlier descended and disappeared for the rest of that day.

The whole episode had lasted less than four minutes. We had virtually nothing to show on film, but the experience demonstrated that trust was not a problem with this white bear. None of the black bears had been quite so nonchalant at finding two strangers in their creek. I was excited by the possibilities of working with an animal that might provide a window into a bear's life in a way that I had only imagined before. In the Khutzeymateen I had seen a willingness in the bears to be gentle with people who showed respect and kindness toward them. However, with guests present at almost all times there, it was inappropriate for me to explore what this meant in terms of being safe around bears. One word often associated with bears is "unpredictable," but it actually describes us better than them. If a bear and a person meet, the bear doesn't know whether he is going to be shot at, have his picture taken, or be snared, drugged and collared. He could be fed and then punished for helping himself, and the list of inconsistent signals from man goes on and on.

As I settled into my seat for the boat ride home, I wondered if this bear had ever been around people before. Jeff and I concluded that it was unlikely. When we were within radio distance of camp, Jeff told Sue that we had finally had some success. Turning the corner into our inlet, we saw smoke drifting above the tall spruces and knew a celebration was being prepared. We stopped at the prawn trap on our way in and, thirty minutes later, with the enticing smell of garlic and prawn in the air, the three of us speculated on what might now be in store for us.

▼ ▼ ▼ ▼ ▼ ▼ ▼ ▼ ▼ ▼ ▼ ▼ ▼ ▼ ▼ ▼

It was another long wait at the creek, but early in the afternoon the white bear I call the Spirit Bear appeared in the canyon and again became interested in what we were doing. Because the water levels were low again, the bears were having trouble catching salmon. The fish were simply not leaving the pools — they appeared to know that they wouldn't be able to make their way over the falls and, even if they did, they would face almost certain death in the jaws of bears.

I was beginning to believe that the Spirit Bear was different in some way from his shyer black brethren. I decided to experiment. He too was having trouble catching salmon in the deep pools. Several coho lying in a small pool had somehow gone undetected by the other bears, and I wondered if I could show him where they were. (Doug Stewart had

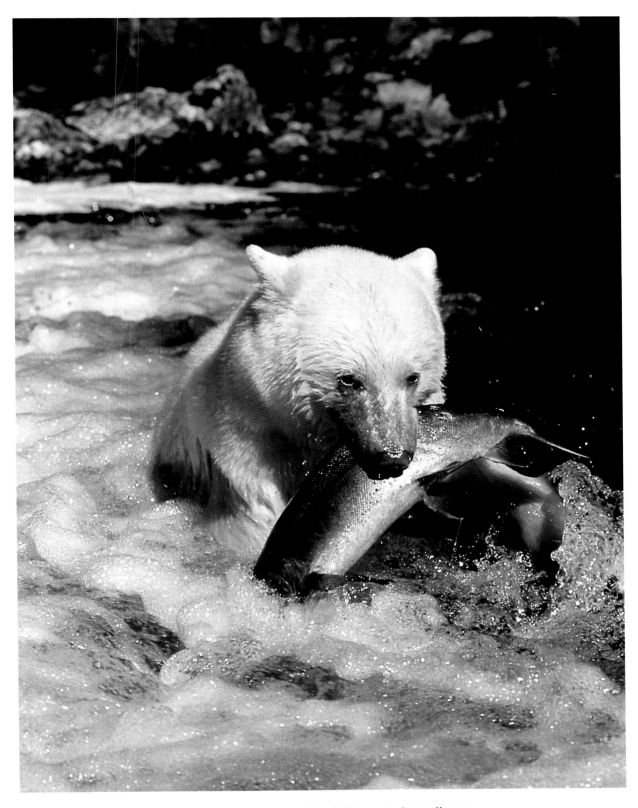

Catching salmon would be easy one day and very difficult the next, depending on whether the creek was in flood or not.

made a point of letting us know that he would appreciate it if we didn't interfere with the salmon. I was hoping he would forgive me this one time — "for the sake of further knowledge," I rationalized.) The challenge lay in not spooking the fish prematurely, so I crawled on my hands and knees in the water toward them. As soon as I splashed with my hand, the Spirit Bear came running over to see what I was doing. He soon caught on that I was searching the nooks and crannies for salmon and joined me in the hunt. We hunted together, his paws feeling into some of the places I missed. I was amazed at how he appeared to understand me when I cautioned him to "go easy." By now, I was thoroughly wet but completely thrilled by what was happening.

As we neared the place where the salmon were hiding, I began to move even more carefully and made a point of staring at the fish, which could now be seen about 6 inches (15 cm) below the bubbly surface. The white bear followed my lead well, but was looking at me instead of the fish, so I picked up a pebble and tossed it 6 feet (1.8 m) to where the fish were lying. The bear watched the stone as it splashed, which startled the salmon just enough that they swirled. With one splendidly swift move, he belly-flopped into the pool, which was not much bigger than his body. The resulting "tidal wave" swept one of the fish flopping onto the bare rocks. In a blur, the Spirit Bear was on top of it.

A black bear watching the scene from a rock 60 feet (18 m) behind us now made a rush to hijack the salmon from the smaller bear. This we later learned was the usual procedure. I brashly stepped between them, remembering how the young grizzlies of the Khutzeymateen had learned to use us for protection from a bully. Both bears accepted my authority at the fishing hole. The white bear started to eat his meal, having assessed instantly that on this day of scarcity he would lose the fish if he ran for the woods. The black bear moved off up the gorge.

I was aware that I was interfering with what might normally happen in this canyon if we were not there, but I reasoned that what I stood to learn from my interaction with the bears was justified. And I contrasted it with accepted and encouraged types of disturbance such as hunting, which could legally take place on the island. Although the white phase of the bear is protected, black bear can be hunted there. Each hunter holding a $30 licence is allowed to kill two black bears a season.

As one might expect, that evening at Camp Chelsea there was considerable discussion regarding the unexpected problem that had arisen. Our white friend was simply not behaving according to our preconceived ideas. He was not acting in a "natural" enough way to

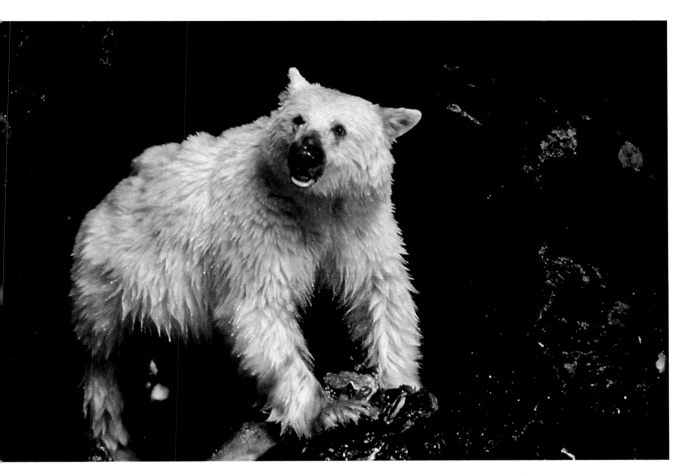

The bears ate three or four meals a day, consisting of two or three salmon at each meal.

provide the filming opportunities we required. The film script had been written to depict the Kermode bear in the wild, at some distance. What we'd encountered was strange and unexpected. We had gone from seeing no white bears at all to having our dream animal appear, only to be thwarted by his incredible curiosity and seeming absence of fear. He was often too close to the camera to allow Jeff to film him, sometimes peering into the front of the lens and on occasion leaving his unwanted nose prints on the lens itself. We realized that we needed to be patient and hoped that, once his curiosity was satisfied, he would begin acting more naturally. All of us could see that this was an opportunity to really get to know a wild bear. For years, I had dreamed of the possibility of studying and working with bears in a way never before attempted. Here was my chance.

I began to consider what "natural" behavior was for a bear that had not had experience with people and suddenly found itself in a position

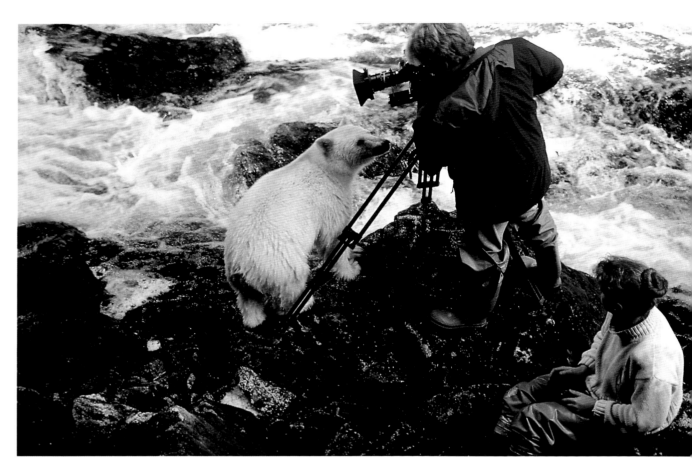

Jeff and Sue had difficulty filming the Spirit Bear because it felt just as comfortable under the tripod as anywhere else along the creek.

to explore these strange and intriguing newcomers to the salmon stream. I concluded that it could conceivably be "natural" for the Spirit Bear to explore this interesting phenomenon. After all, he had neither learned nor encountered fear and hostility in his contact with us. But what about me? I too wanted to be as free as this young bear — open to the unfathomable possibilities before me.

I live on the edge of a magnificent national park, a park where large numbers of visitors hike and camp each year. Perhaps not surprisingly, Banff's wildlife management personnel strive to maintain as much distance as possible between people and bears. In the park mandate, "getting along with bears" means keeping a distance of at least 100 yards (90 m) between visitors and bears. A "good" park bear is one that always runs away. Perhaps in a national park where the average visitor is a city dweller with little or no experience with wildlife and wilderness, it is the prudent management option. But there is a growing

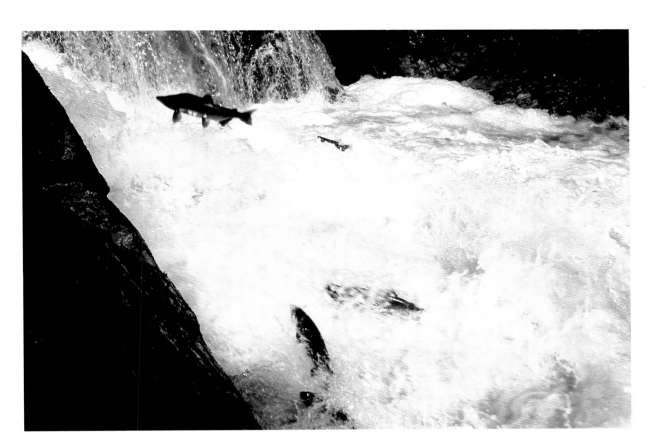

Try as they would, the pink salmon could not get up the first falls on Camp Creek.

body of evidence that people can be close to bears and still be safe, providing we conduct ourselves properly. Years of bear viewing at McNeil River, Brook's Camp and Admiralty Island in Alaska have been accomplished without any serious injuries to humans. Often these bears are hunted in nearby hunting concessions, where some individuals have even been wounded, yet they return peacefully to the bear-watching areas with no apparent grudge against people.

Just before falling asleep that night at Camp Chelsea, I heard the soft patter of misty rain on my tent. There was a good chance that before morning I would be awakened by a pounding downpour confirming the arrival of the wet season. The following morning, it was apparent that the front was delayed, so after breakfast we quickly loaded our gear into the *Sea Hound* and headed for Canyon Creek through the mist and rain. The sky was ominously dark and gave little doubt that our general forecast was correct. The first major frontal system of the rainy season was on its way. It would be interesting to observe the movements of the salmon and bears in relation to the

approaching storm and rising water in the canyon.

When we motored into the mouth of the creek, it was immediately evident that activity was at a much higher level than during our previous visit. The water level had risen only a few inches, but the salmon sensed that they would soon have another chance at forcing their way up through the canyon to the many miles of spawning ground beyond. Thousands were now milling at the mouth of the creek. The coho were leaping up the first falls with steady persistence, but approximately two thousand pink salmon attempting to gain entry had virtually no chance of success. When it comes to overcoming obstacles, pinks are a weaker species of salmon; these had somehow made the mistake of picking a creek with a steep and cascading entrance. They were destined to fail at this one chance to reproduce unless they sensed the futility of remaining there and chose another stream with easier access to spawning grounds. Pinks appear to be the exception to the rule that salmon always return to the exact place where they were spawned. Their forebears had clearly not been up this canyon!

The bears were having a field day with all the fish now on the move. The Spirit Bear seemed to be caught up in a rivalry with the young black male that I had earlier fended off. The black bear would steal almost every salmon he caught. Busy catching salmon for two, the white bear ignored us for a change until at last, to escape the thief, he brought a fish over to eat beside us.

Although it had turned into a very wet day, we were protected by the overhang for a distance of about 75 yards (70 m). The wind was increasing, but Jeff was not about to quit filming, given that this was our first real chance to film the Spirit Bear in five months, not counting the times the bear had been too close. But were we taking a chance with the weather? This country can chew you up and spit you out in small pieces. I reluctantly left Jeff and the bears to check on the boat, the wind having swung around to the southeast, exposing the *Sea Hound* to huge waves that could dislodge the anchor and send the boat crashing onto the rocks.

I carefully navigated an obstacle course of slippery boulders and a slanting log 20 feet (6 m) above the now raging waterfall at the mouth of the canyon. The log was worn smooth by the paws of thousands of bears, which were infinitely more adept at staying on the log than I in my gum boots, but it was the only way across. I imagined myself careening into the foaming turbulence below, or joining an unsuccessful salmon when it slammed into the granite in an abortive

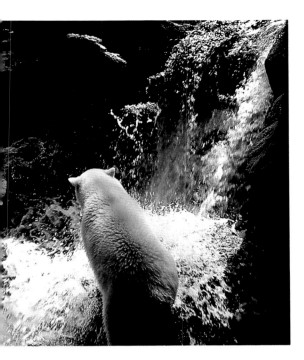

The Spirit Bear scouts a cascade for fish.

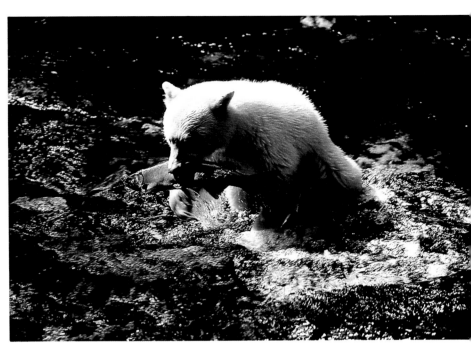

Of the nine bears that caught fish in the canyon, none was as adept as the Spirit Bear.

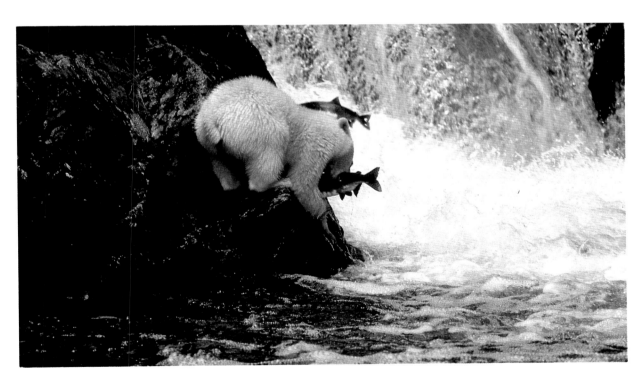

Black bears are as intelligent as grizzlies in figuring out ways to procure a meal.

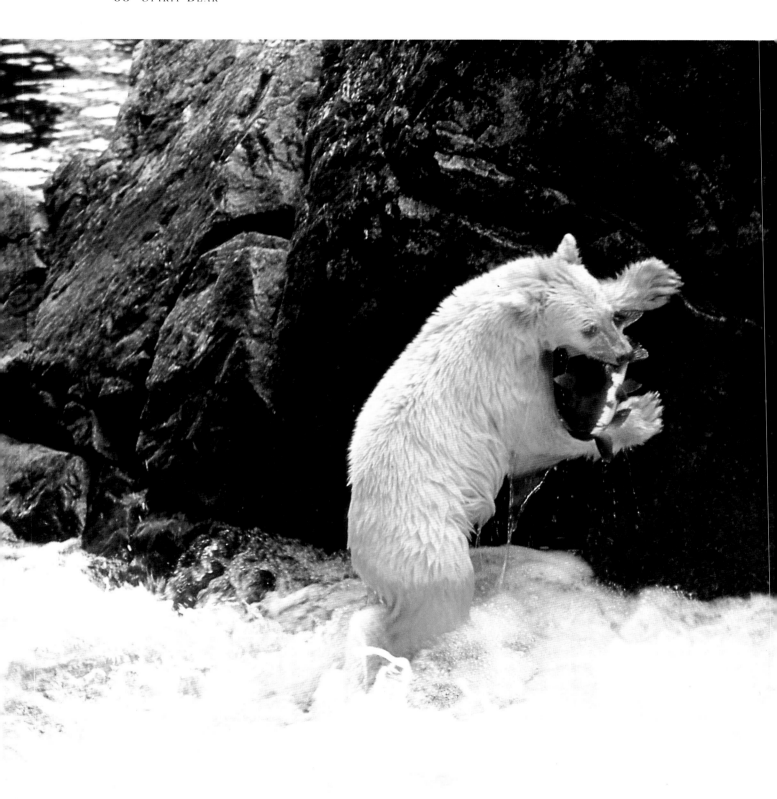

A young, agile bear could get into fishing holes that others wouldn't attempt to reach.

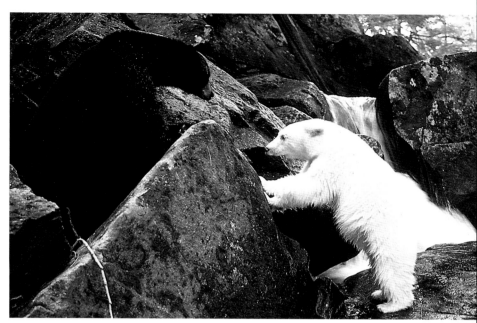

The Spirit Bear and this young black bear were fishing rivals at the canyon.

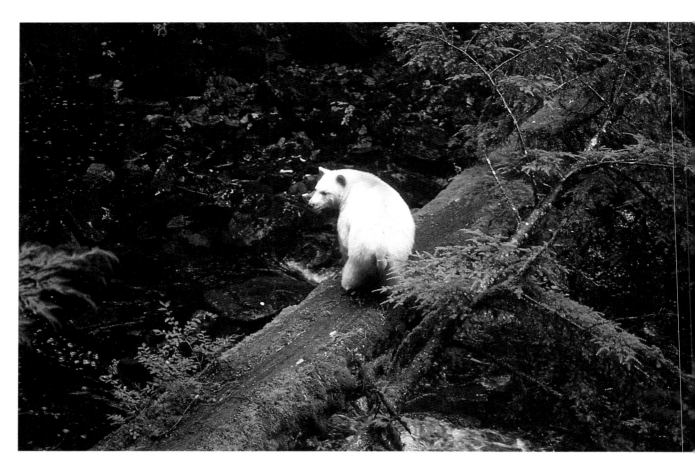

The Spirit Bear on the log spanning the canyon.

attempt to clear the falls. I was also imagining Jeff being washed down from the canyon because by now the water had risen about a foot (30 cm) in three hours and would undoubtedly continue to rise at a steady pace in the heavy rain.

The scene in the bay was wild. After reassuring myself that the mooring was secure, I turned back upstream. The Spirit Bear was standing in the middle of the log which I had precariously navigated only minutes earlier. From his perch, he was intently watching the salmon as they struggled to clear the falls. As I, in turn, watched the bear watching the fish, there was no question in my mind that he was figuring something out. I might not have existed for all the attention he paid me. Striding up to my end of the log, where I was standing on the rocks, he stepped by me, brushing my leg as he passed. He repositioned himself on a point of granite below me, about halfway up the torrent. A large salmon leapt within a few inches of the bear's nose. He snapped at it and missed. A second fish slammed into the side of

the bear's white furry head, another into his side, the force of which almost knocked him from his perch. Then he caught one. The bear had been patiently waiting for a salmon to miss its leap and rebound off the rock, which would send it directly into his waiting jaws! He barely had to move to snap it up.

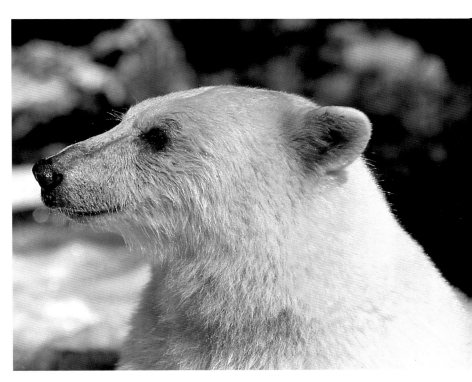

Francis Kermode, whose name was given to the white bear, never saw one in the wild.

During my many years of watching grizzly bears catching fish, I had never seen demonstrated the deductive intelligence that I had just witnessed in this bear. I had always considered black bears to be the lesser in cunning and mental ability compared with their larger cousins. I was now doing some major rethinking, a humbling experience that was becoming increasingly common on the island. I thought of the young black bear that had earlier figured out how to get the Spirit Bear to do his fishing for him. He was no longer in sight; most likely he was full and content, sleeping somewhere in a dry place.

The thought of a warm, dry place made me realize I was feeling worn out and soaked to the skin. Jeff had managed to make his way safely downstream, and with all the skill two inlanders could muster, we stowed our gear in the boat without getting anything wet or smashed on the rocks and headed for Camp Chelsea. As my mind went back to the moment nearly a year earlier when Jeff, Sue and I had first decided to take on the challenge of a film on the Kermode bears, I recalled thinking it wasn't going to be easy. But none of us had dreamed it would be this enlightening or adventurous. I thought to myself: "This is truly living."

With our luck in having found such a co-operative subject, the possibilities for filming seemed endless, bound only by the limits of imagination — and strategies for keeping the Spirit Bear far enough away from the lens to photograph him. What I found most interesting was that such a relationship could be established entirely without bribing the bear with food. Film-makers are notorious for manipulating

their subjects with bait or trapping them, or even domesticating them. Because finding food is so important for bears — to gain weight for their long winter hibernation or to nurture cubs — feeding them to be accepted can seem almost irresistible. Lynn Rogers, a biologist in Minnesota, is renowned for his close work with black bears in the midwestern United States. By radio-collaring the bears and feeding them by hand, he was often able to stay with his study bears continuously, sometimes for days. This enabled him to conduct valuable research, which yielded answers he could only have guessed at otherwise. As I read of his results and watched videos on his work, I couldn't help wondering if an even better relationship with a wild bear could be established by other means. I didn't like the "crankiness" I observed in Rogers' bear subjects; they appeared to be "bluff-charging" him a lot, and this made me uneasy.

Also, bears can quickly come to rely upon food handouts, and the relationship then becomes that of giver and taker. There is no question that bears are aggressive animals; if the giver quits giving, then the taker is probably going to try to take the food even though it hasn't been offered. Over the years I have come to believe that many problems associated with bears are the direct result of a dependence on human food or garbage.

I wondered if I could rely instead on what I would call a "universal interest or curiosity" that seems to exist in all creatures of the higher orders. Over the years, I had observed the bear's curiosity in action on many occasions as individuals or groups of different species "checked each other out." Being blessed with such wonderful animals as we had discovered on this island, I felt it was important to grasp a unique opportunity to condition them not to our food, but to the interest, curiosity and friendship of *Homo sapiens*.

One sunny morning as the water in the creek was again receding, we were waiting patiently for three things to happen at once. Hundreds of feet of bears fishing were already "in the can," but what we now needed were some underwater shots of the Spirit Bear catching fish in the crystal-clear pools. Jeff was sitting at the top of one of the pools with his underwater camera between his feet. We hoped to co-ordinate the arrival of a fish within filming distance (2 feet/60 cm) with the arrival of the jaws of the white bear clamping onto it. As we waited, I laughed, not at the temerity of our expectations, but at the Spirit Bear. He slowly waded into the pool, with his face underwater up to his ears, which allowed him to view the underwater spectacle much like a

Jeff films while the Spirit Bear snorkels his way toward him.

person with a snorkel mask. It was the oddest-looking fishing technique I had ever seen.

This particular pool was also the eating place of a large female black bear, who wasn't about to stand idly by as two human interlopers made a movie about white bears. She nearly ran us over in her eagerness to chase the white bear away. The two displayed considerable aggression toward each other, which I was relieved was not directed at us. So persistent was the black bear that we stopped filming and watched the show. Finally, satisfied by a belly filled by three or four salmon, she departed. Sue and I decided that this was one

Jeff and the Spirit Bear watch for a salmon that would make an underwater subject for one and a meal for the other.

female that did not need assertiveness training in dealing with a male!

After things settled down, the Spirit Bear, instead of resuming his search for fish, wandered over to Jeff and sat down, elbow to elbow.

The Spirit Bear was often more interested in the camera than in chasing salmon.

Then he reached down with his paw to feel the camera underwater. As if to ham it up even more, he slid into the water, snorkeled to the lens and put his nose up against it. Impatiently, I wondered how long this diversion would last, since I suspected he still had an empty stomach.

The bear then snorkeled toward me as I knelt in the water at the foot of the pool, leaving Jeff with only a large butt end to photograph. Suddenly the bear lunged and grabbed my foot, probably mistaking it for a fish in the frothy water. For the first time in my relationship with the Spirit Bear, I felt fear. After all, I had seen him effortlessly shear off the head of a salmon with those very teeth. To my great relief, he barely pinched my foot before spitting it out like a hot potato, apparently

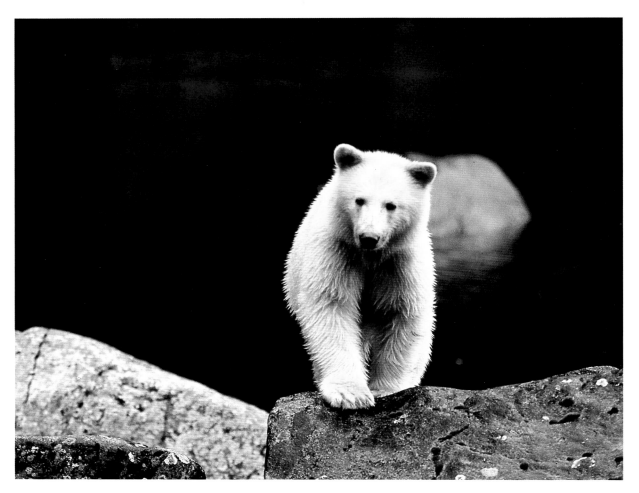

The Spirit Bear at the mouth of the canyon.

realizing his mistake almost instantaneously. I resumed breathing again and could feel the uncontrolled rush of adrenaline subside. Such experiences helped build the unique relationship of trust we enjoyed with this bear.

Shortly thereafter, Jeff got the underwater shots of the Spirit Bear catching a salmon. As he wound his footage, I wished I had an underwater housing for my still camera. Later that day Peggy and Heine arrived to find us sitting on a rock near the *Sea Hound*. They did a double take when they realized there was a fourth member of our party — the shining Spirit Bear himself. He would sometimes hang around us for no apparent reason, seemingly just to enjoy our company.

Peggy had always believed there was something special about the bears of Princess Royal but had decided discretion was the better part of valor, and had not personally tested the validity of her beliefs. During

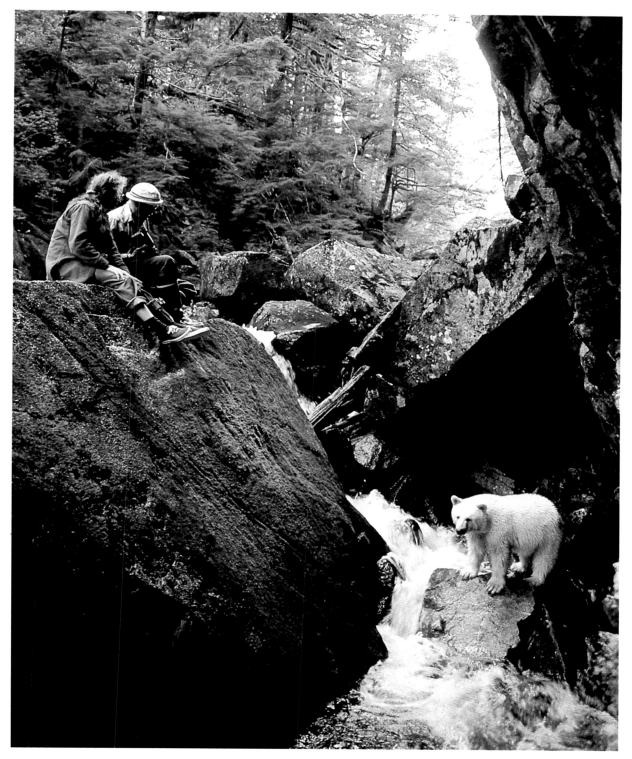

After years of coming to Princess Royal and looking for white bears, this was the best opportunity Peggy and Heine had ever had to observe their elusive quarry.

hundreds of hours of bear-viewing, she and Heine had always kept their distance. Now I could sense their eagerness to do some of the things we had done. I am very reluctant, though, to suggest to others that it is safe to be close to these powerful creatures. So much depends on a person's understanding of them; for example, it takes a lot of experience to discern their changing emotions. Even then, one never knows for sure, as illustrated by my few seconds of doubt when the Spirit Bear had me by the foot.

When a bear approaches me, I ask myself the following questions: "Is the bear approaching because it does not know what I am and is coming to investigate?" or "Does it feel threatened by my proximity, and has it decided that the best defense is a good offense?" or "Is it running at me to escape from another bear — am I in the path of its retreat?" or "Is it approaching because it is glad to see me?" I feel I have the knowledge to judge, knowledge gained from experiencing all of these scenarios and more. Thus far I've been able to assess the intent of a bear running toward me. Some of my lessons have been more difficult than others, such as the occasion when my son and I were attacked by a black bear. But even then, I instinctively knew after observing her first two leaping strides toward Anthony and me that we were in the wrong place at the wrong time. What one does during the first seconds of encountering an angry bear can mean the difference between a potential fatal mauling and a possibly frightening but harmless experience.

For these reasons I was nervous about suggesting to Peggy and Heine that they too could get close to the Spirit Bear. Our success may have been due to my experience and relaxed, confident manner around bears. I firmly believed then, and still do, that any inexperienced person who wants to attempt close bear-viewing should do so in the company of a guide who is knowledgeable about bears. Because I was fairly certain that Peggy and Heine would return to this spot without Jeff or me around, I was faced with a troublesome dilemma.

For the next few days, the Doles watched how Jeff and I worked around the bears and asked me a lot of questions. I hesitated, but decided to at least share with them my newly formed conclusions on the bears of Princess Royal and particularly the Spirit Bear. I said: "These bears are special. They do not possess the bad habits we expect of bears who are ill-treated by humans. To maintain this desirable state of affairs, it is very important never to let these bears get even a mouthful of your food. Talk to the bears. Tell them how close you want

them to come, and never allow them to take any part of the clothing you are wearing into their mouth. Strive mightily to be relaxed around bears. Let them decide how close they want to come to you and if you feel uncomfortable, tell the bear: 'That is close enough!'" I decided I could live with myself in passing on this advice, as I trusted these two friends of mine to follow it closely.

I also lent them a bear spray called Counter Assault. The spray's active ingredient is a very strong pepper. Although I have never had to use mine, it has been proven many times to be a very effective way to protect oneself against the rare situation of a bear attack. If it had been developed when Anthony and I had our bad experience, there is no question that we could have easily protected ourselves and caused no harm to the bear. Because this spray can be seen, it's much easier to direct than a gun, and so far it seems to be more effective in the average person's hands.

▼ ▼ ▼ ▼ ▼ ▼ ▼ ▼ ▼ ▼ ▼ ▼ ▼ ▼ ▼

On Princess Royal Island, the salmon can't all enter the creeks at once, especially in fair weather when the water levels recede. In these conditions the fish gather in huge numbers at the mouths of the creeks to await their turn at moving up. The salmon often become so densely packed it looks as though one could walk across them. They make a veritable carpet of writhing backs and fins. It was comical to watch the Spirit Bear swim out into the middle of all these fish. They would part around him as he slowly paddled through with his face underwater in his snorkeling position. Was he trying to think of a way to catch them, or did he just enjoy the spectacle of unlimited food — "window-shopping" as it were?

Being around bears for hours every day facilitates zeroing in on different aspects of bear behavior. The interaction between the bears as individuals started to attract my attention. Some of the bears got along well. They rarely came to serious blows and, even then, I didn't see a single episode where one bear physically injured another. On the other hand, there was a constant struggle between the Spirit Bear and the young male black bear that was his rival.

Much of the canyon was a jumble of huge granite boulders, which provided not only resting pools for the salmon migrating upstream, but also good fishing spots for the Spirit Bear. I sometimes feared he would drown when he submerged and squeezed himself into a crack between

When the creek levels were low, the salmon had to struggle to reach their spawning grounds.

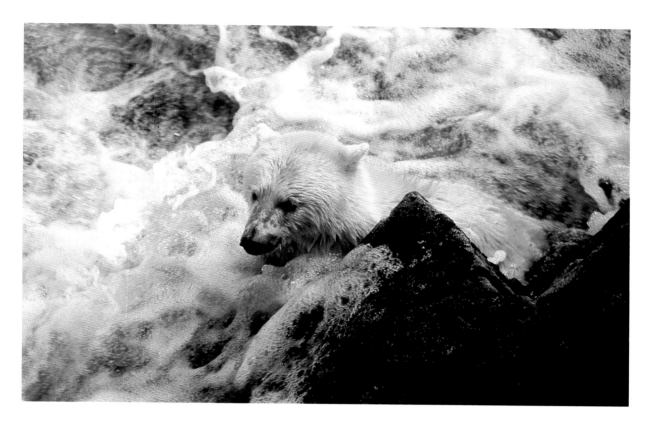

The Spirit Bear waits in the water for a salmon to pass by. In the fall, in preparation for winter, bears eat three times as much food as they do at other times of the year.

the rocks, completely disappearing underwater for a minute or two —
or so it seemed. With the young black always lurking nearby, the Spirit
Bear would invent ways to protect his hard-earned dinner. On occasion
he would climb a large cedar and ascend to a height that the black bear
was afraid to match. He always chose the same tree for his high repast.
There he would perch on a moss-covered branch, 20 feet (6 m) above
the ground on one side with a 50-foot (15 m) drop into the canyon on
the other. I worried that he might fall. A lump would rise in my throat
at the mere thought of losing a bear that I was beginning to view as a
friend. I felt much better when the Spirit Bear brought his fish to my
side, using me as a shield from the black bear.

One afternoon there was a particularly low tide. I was worried that
the *Sea Hound* would get hung up on a boulder and tip over if the tide
receded any further, then fill up with water when the tide came in
again. (Heine had already rescued us once from this near disaster, after
scolding us for being too preoccupied with our work.)

On this particular day, I had left Jeff with his tripod and camera in a

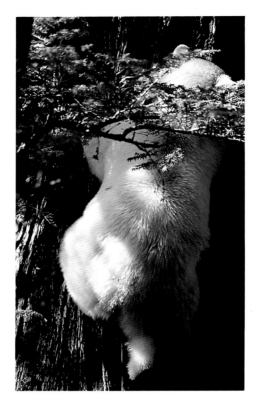

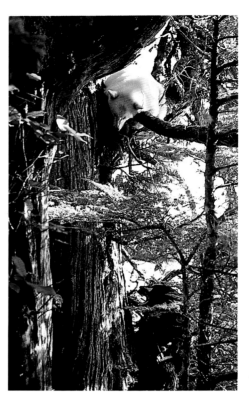

For the Spirit Bear, the safest place to eat a salmon in peace was often high in a cedar tree.

Sometimes the young black bear, who rarely caught a fish of his own, would follow the Spirit Bear up a tree in pursuit of a meal. However, he never ventured as high as the white bear.

tight crevice near the top of the canyon. He was filming the Spirit Bear attempting to catch salmon in the recess. When I returned thirty minutes later, Jeff's eyes were as big as saucers and his voice rather squeaky as he recounted what he referred to as "the scare of my life." Jeff has one of the coolest heads I've ever encountered in the bush, so I knew this wasn't going to be a story about a spider in his eyepiece.

It turned out that the Spirit Bear had caught three fish by doing an unbelievable contortion to enter a small underwater pocket in a very narrow slot between the rocks. Jeff was awkwardly perched in rushing water between two high boulders. The Spirit Bear carefully placed all his fish on a flat rock in front of the camera and commenced eating, clearly feeling confident he was safe from his black rival, who was watching them from a perch behind Jeff.

Through his viewfinder, Jeff suddenly saw the Spirit Bear's ears flatten against his head and his back arch up. Simultaneously, Jeff felt

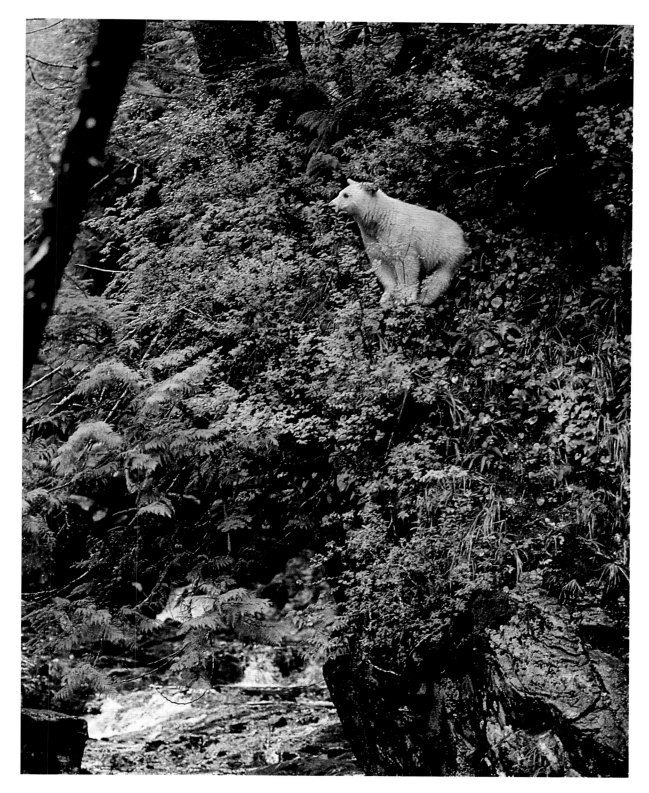

The white bear appeared to shine amidst its dark surroundings.

something bump into his left side — the young black bear could contain himself no longer. The hoard of fish was too much for him. Deciding to take his chances, he leapt by Jeff, knocking him down (along with his camera). The Spirit Bear had nowhere to go and an incredible battle ensued with much high-pitched squalling that sounded more like two tomcats fighting than a rumble between two male bears. Jeff grabbed his valuable, and irreplaceable, camera by the tripod legs and hung on to save it from ending up in the drink as the bears rolled into him. In my mind's eye I could well imagine my partner in the middle of a tangle of white and black bear fury, desperately clutching his camera as if it were his lifeline. Ten seconds of fighting bears at one's feet must feel like an eternity.

I would have loved to have seen this contretemps with Jeff in the middle, camera still rolling even though he didn't have his head to the eyepiece. I marveled that two bears could engage in a knock-down-drag-out battle over food, and yet leave Jeff uninjured. He didn't even suffer so much as a scratch. Not surprisingly, however, he was quite shaken, having literally been up to his waist in fighting bears. With all those snapping jaws and raking claws, how had they avoided him? I knew from experience what can happen when one gets too close to two fighting dogs. It made me appreciate even more the relationship we were building with these denizens of the wild.

Until then I had made a point of not following any of the Princess Royal bears. I allowed them to decide the distance that they wanted to be from me. I always waited until they approached me, having decided this was an effective way to avoid harassing them. I knew a little bit about their boundaries, and didn't want to cross into uncharted territory. Although bears in general do not have individual territories with clear boundaries, mature bears seem to command a certain amount of space around them which they try to keep free of other bears. The amount of space varies with the size and dominance of each bear, but every year in the fall, when they crowd into tight fishing areas, they have to re-adjust to being in closer proximity to one another. Our family had observed similar accommodation among bears in the berry patches back home.

The Spirit Bear presented a particular conundrum. He appeared to have satisfied his curiosity about what made me tick, while mine was only whetted. I wondered where he spent his time and what he did with the many hours away from the fishing hole. I lay awake at night in the dripping wet tent at Camp Chelsea, tossing about in the confinement of

my sleeping bag and wondering what I should do. Increasingly I yearned to push back the frontiers and learn more about this white bear. What was he up to when I wasn't around? I had many dreams about the Spirit Bear, but one stands out in my mind:

> The white bear was speaking to me, asking me to follow him in his search for a winter den. I got up, crawled out of my sleeping bag and followed him deep into the wet, mossy forest. We traveled high up into the mountains, and the search went on for a very long time. The rain turned into snow and the winter cold made us both feel an urgency in our quest. Finally, digging down through some deep, crusty snow, we broke into a large, warm cavern. It was foggy and humid. A light seemed to be filtering through the mist from many different directions. It frustrated me, as I had trouble seeing around the cavern in the dense fog. The bear told me that this was the place where all the white bears of the island gathered to spend the winter. I wanted to count how many bears were in the cave, but fog kept drifting across my vision, blocking me from seeing into the many chambers of the underground cavern.

I don't place much store in dreams, but I thought a long time about this one. Taken literally, the dream suggested that the bears might be going high into the mountains to den in the snowbelt in order to avoid the wetness of the lowlands. On a more personal level, though, I wondered if perhaps the dream was an invitation: Was I being invited by the spirit of the bears to follow the white bear?

To follow a bear would be to act against the advice of bear experts such as my friend Wayne McCrory. I continued to agonize about whether or not I should break the rule, and if I did, how I could justify my decision to Wayne. Wayne's views are consistent with those of many biologists and park wildlife managers. The consensus within this group is that people and bears can co-exist if we avoid habituating grizzly and black bears. The word "habituation" is very loosely defined, even among the technical experts. One definition that is widely accepted is "the loss of fear of man, either through association with a food source or by other means, such as frequent exposure to people." The belief is that when bears lose their fear of humans they can become unpredictable and dangerous. The argument then follows that with these potentially dangerous bears around, maulings and even human deaths will inevitably occur. The delinquent bear is usually destroyed, an unfortunate occurrence that adds to the bad press the whole genus

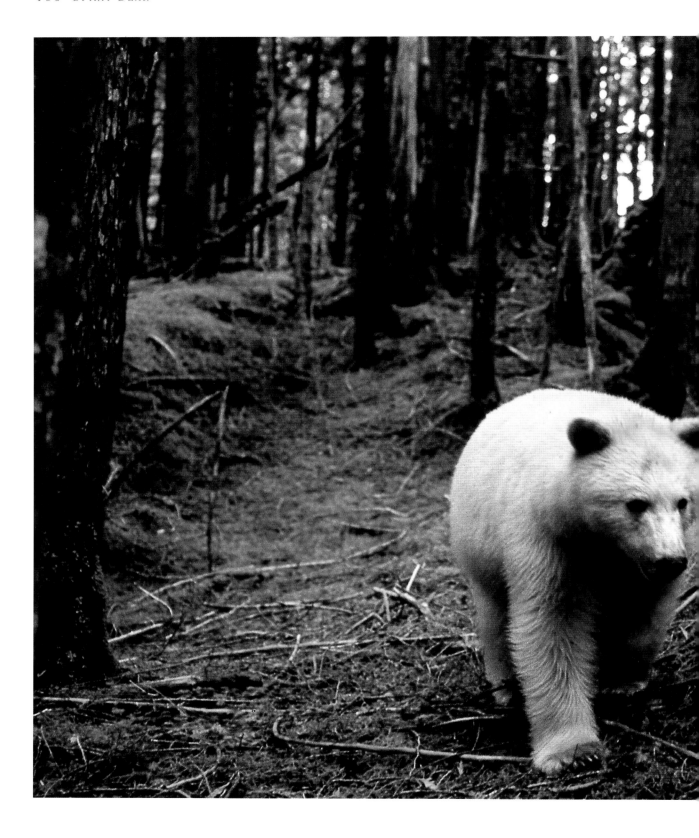

This forest had been burned over approximately forty years earlier and was unusual because the underbrush had not yet grown back.

continually receives. This in turn doesn't help dedicated conservationists in their attempts to persuade provincial or federal governments to set aside valuable forest habitats for bear sanctuaries.

I finally made up my mind: Jeff and I would follow the Spirit Bear into the forest. I felt confident that I had arrived at a flaw in the current definition of habituation and that this knowledge, demonstrated through my work, might add to the ongoing scientific research on bears. I believe that the "loss of fear of man" is not necessarily a learned response among wild animals, but rather that "fear of man" is the learned behavior. I was convinced that this particular white bear had not experienced any close human contact before our arrival on the island and that this was true of many of the Princess Royal bears. Fear of us was the furthest thing from their minds. I wanted to continue to unravel this mystery. The Spirit Bear was an exceptional animal to study, and I knew I might never be presented with another opportunity like this one in my lifetime.

In my eyes, the Spirit Bear was also a potential ambassador for the island. His image and friendly reputation could pave the way for efforts to save Princess Royal as a white bear sanctuary. In addition, the Spirit Bear could educate future generations through the film and my photographs and writings about what is truly possible of a "wild" bear.

After much thought, Jeff and I gave ourselves the green light with two promises — we would never let the Spirit Bear identify us as a source of food, and if we appeared to cause any stress to the bear by following him, we would abandon the quest.

The first attempt to follow the white bear ended up as one might expect — he simply hoofed it up the steep crack in the rocks that was his usual route, and we found it impossible to keep up on the slippery rock. He disappeared from view, seeming to vanish into the mountainside.

One morning, however, he left in the opposite direction. This side of the canyon, although also steep, had been burned off about forty years earlier and was still remarkably clear of the usual jungle of dense undergrowth. We followed him up to a bench above the creek. This bench is a soft, moss-covered paradise with light filtering in through the canopy of trees overhead. My fears of harassing him soon subsided. He seemed quite relaxed with the two of us trailing along behind. In fact, I had the distinct impression that he was enjoying our company. When we talked to him, he would appear to listen intently.

We kept our distance and followed the Spirit Bear on several

different days. Arriving at his creek after a 25-mile (40 km) trip by sea, I looked forward to seeing him, my expectations shortening the long journey. Often I thought our feelings were mutual. He would come running up to us even if we had been away for two or three days. We were spending time with black bears and other white bears on various parts of the island, but always found ourselves drawn back to this bear. Jeff and I were the only people left on the island now. Peggy and Heine were sailing south, and Sue and Chelsea had just left.

The Spirit Bear was by now clearly accepting us on his jaunts through the forest, even though we were quite noisy and awkward about it. Laden down with heavy cameras, we struggled over deadfall and scrambled up and over slippery rock outcroppings. I often felt I needed four hands — two to lug the gear and two to stop me from tumbling down the slope. At times, struggling to keep up, we would laugh to find the white bear lounging on top of a log, waiting for us. He would often top up his salmon-filled belly with some purple salal fruit, skunk cabbage or the leaves of red huckleberry bushes, which he stripped off with great dexterity.

Sometimes, without warning, he would flop down for a nap, often within 500 yards (450 m) of the creek, but rarely in the same location twice. One common feature of these resting places was that they were always some height above the surrounding terrain, giving him a perch from which he could easily spot any approaching bears. If rain was falling, he would choose a dry vantage point, often under a canopy of trees or under an overhanging ledge. The peacefulness of these wonderfully mossy places was tempting and we too would settle down for a siesta.

The first few days that we followed the Spirit Bear, though, I didn't do a lot of resting. I was intent on watching him in his sleep and didn't want to miss anything. I couldn't believe how trustful he was to fall asleep in our presence. Finally, I began to stretch out a couple of feet from him, being careful not to bump into him as he slept. I could even carry on a conversation with Jeff and not awaken the bear, but a distant snap of a twig would bring him to instant attention.

I could easily observe the exact point at which he fell asleep. His breathing would become deep and regular. If he was on his back, he would snore, just as I do in that position. He slept on his side mostly, with his legs stretched out like a dog's. When he was having a dream, his legs twitched, his nostrils quivered and his eyeballs moved around in their sockets. He sometimes slept with his eyes wide open. I could

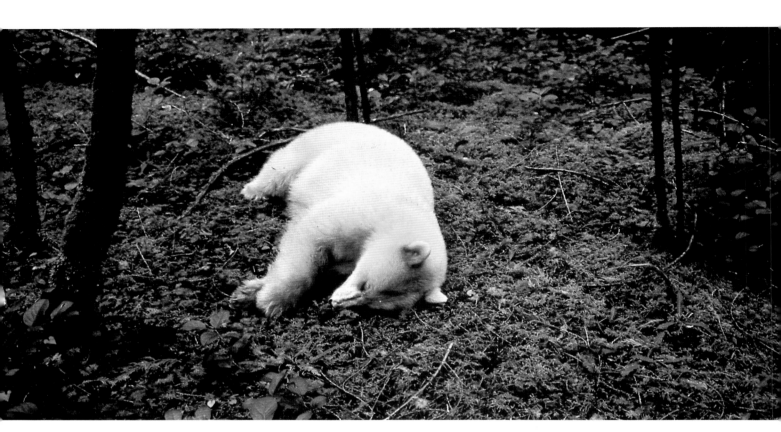

The Spirit Bear napping in a mossy glade.

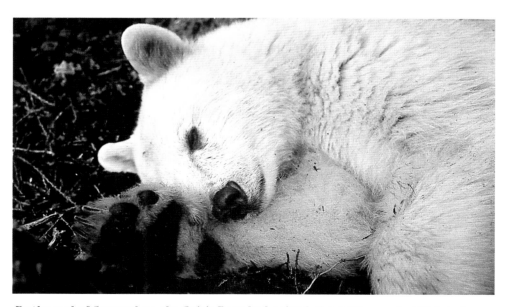

The Spirit Bear's claws.

By the end of September, the Spirit Bear had gained about 50 pounds (23 kg) since our first encounter with him.

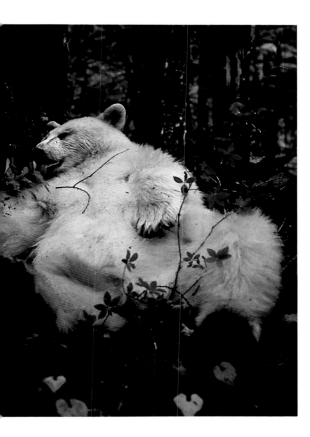
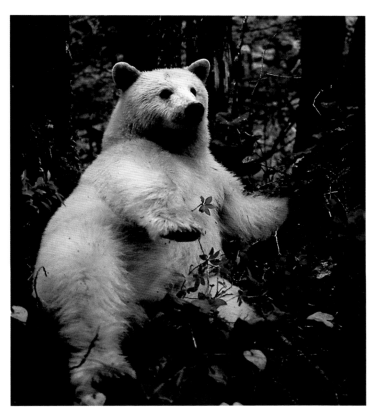

Even the distant snap of a stick would wake the bear.

wave my hand only inches in front of them and it would elicit no response. His eyes were not focused on anything, nor were they rolled up in an unnatural way. Sometimes his dreams seemed to become quite wild, and his legs would flail about and loud grunts would come from his throat. I wondered what he was dreaming about — surely not chasing rabbits!

At home with my cat, I had felt the urge to tickle her between the toes while she slept, just to be annoying I suppose. With this bear, the result was different: instead of pulling his foot away, his sleepy kick was more to contend with. As with my cat, I felt I was harassing him with this experiment and decided not to repeat it.

One day the Spirit Bear led me into an area where I hadn't been before. The ground had an almost unbroken covering of moss, with rocks and trees poking up through it. This seemed to be a well-known home range to the white bear. Exploring it with him had the ethereal quality of a splendid dream. It was one of those times in life when I felt it was too good to be true. I was no longer following this animal, we

were going on walks together, and he was showing me parts of his world in a way that reminded me of the dream I had had the week before. At one point, I noticed that he was walking in the footprints of a marked trail. The terrain steepened when we crossed a certain ridge, but it was still mossy and easy going under the canopy overhead. After we went through a notch separating the canyon and a lagoon, formed by the complicated shoreline in this area, the white bear found another wonderful spot for his afternoon nap.

I was brought back to reality with the realization that my job here was to guide Jeff. Using a hand-held radio, I called him, back at the boat, where he was attempting to clean a lens that was internally fogged. He had started up the *Sea Hound* and was drying the lens in the heat of the boat's motor. I gave him careful directions on how to locate us. If Jeff could locate the right notch in the canyon, he would be with us in no time. I had no doubt that he would find it easily. Spending as much time in the bush as we had for the past six months, we had developed a somewhat uncanny sensitivity to the land. In fact, we now felt so much at home in the rainforest that we expected we would have to acclimatize upon re-entering civilization.

As the Spirit Bear napped, a young Sitka buck wandered down the small ridge which ran parallel to the one we were on. The bear heard him instantly, stood up and watched the deer until it disappeared down the slope. He lay down again and was soon asleep. About fifteen minutes later he abruptly leapt to his feet, this time staring down the opposite side of the ridge in the direction from which I expected Jeff to approach. He was clearly hearing sticks breaking, sounds that were inaudible to my ears, and was likely fearful that another bear was approaching. Concerned that the bear might run off, I called Jeff on the radio and told him to call to the Spirit Bear, telling him who he was. The bear instantly flopped down on hearing Jeff's voice, and resumed his nap.

I suddenly felt a wave of emotion wash through me. What was happening that he could trust us, but not his fellow kin? I wasn't confident that I would ever be able to answer that question, but I was doing a lot of thinking about it. When Jeff appeared over the ridge, the bear didn't even so much as open an eye.

I loved to sit on the huge log that spanned the top of the canyon, watching the bald eagles fly under it. If I crouched behind a large branch that protruded from the log mid-span, they couldn't see me as they winged their way up the creek, flying right under me. The day I

A bald eagle snatches a rock fish from the surface of a cove.

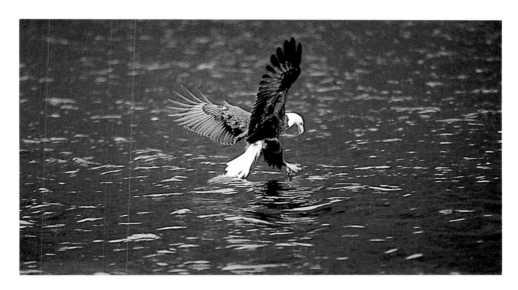

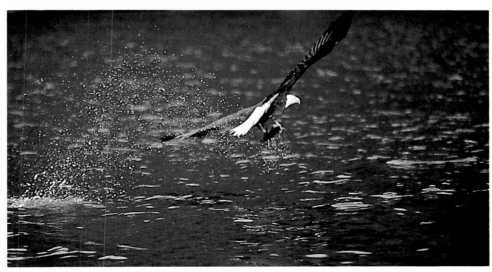

The Spirit Bear in his cave.

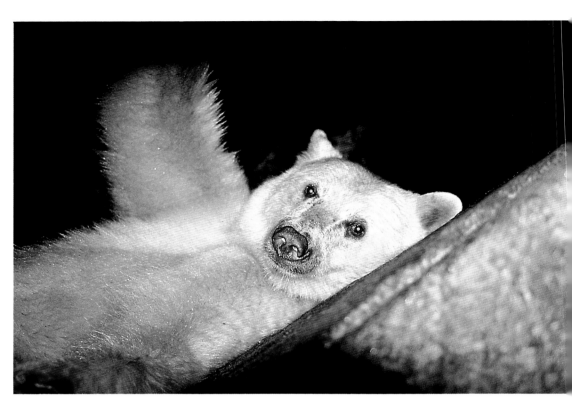

discovered this vantage point, I spotted the rival black bear coming up
the creek. He had no sooner stuck his head in a hole in the rock, under
a hanging wall, than he came flying out backwards, as if stung by a
hornet. He vanished into the forest not far from my end of the log.

Needless to say, I went to investigate what had startled the black
bear. I was careful in my approach, suspecting that there might in fact
be hornets in there, although there was no sign of them. The hole
turned into a cave. As I peered around while my eyes adjusted to the
darkness, I received quite a surprise — the Spirit Bear was staring
back out at me. I had discovered his wonderful cave where he felt safe
enough to rest.

It was a very tight squeeze to get far enough into the cave to look
over the space where he had made his lair. I felt somewhat
apprehensive, having just witnessed the black bear's panicked
departure. The best course of action seemed to be to slowly test his
acceptance of me. First I stood firmly blocking the entrance to the
cave. When he stayed quietly where he was, I began struggling through
the opening. I could see the bear in the shafts of light coming in from
somewhere above. Although a deep trust had developed with the Spirit
Bear, I still felt quite vulnerable. I don't know whether he sensed my
fear or whether it was just his sense of humor, but he waited until I

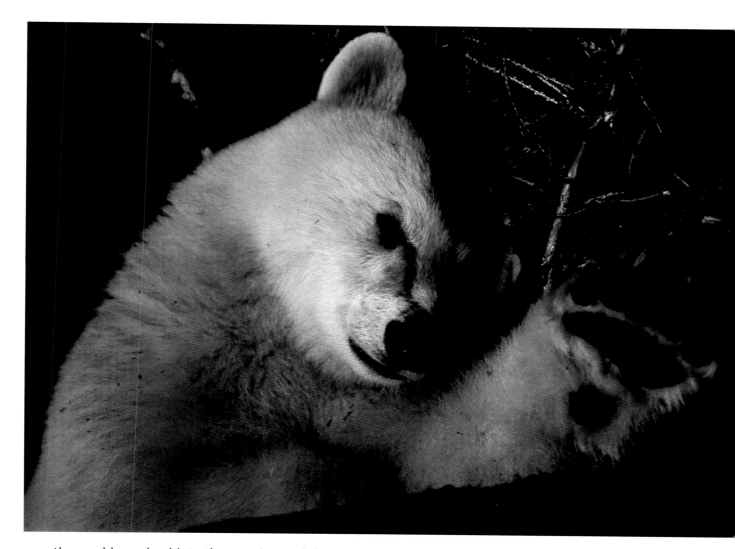

was thoroughly wedged into the opening and then made a quick, small movement toward me, just to see what I would do, or so it seemed. I flinched and banged my head, which made me swear at him. He rolled over onto his back, lounging comfortably in his cozy hide-away. I carefully tried my built-in flash; when he did not react in the slightest, I took a few pictures of him. However incredible these things were that I was observing, I felt that I was still only seeing the tip of a huge iceberg, and I longed to see what was hidden under the surface.

On first awakening from a nap, the Spirit Bear would usually indulge in a ten-minute scratch while lying on his back. He really got into this project, which was amusing to watch. His favorite places were his sides — which he scratched with his hind feet; his chest — which he did with all of his feet; and his face — which he went over with his front claws. Near the end of our filming season, while watching him

The bear would spend ten minutes or so scratching himself all over when he first woke up from a nap.

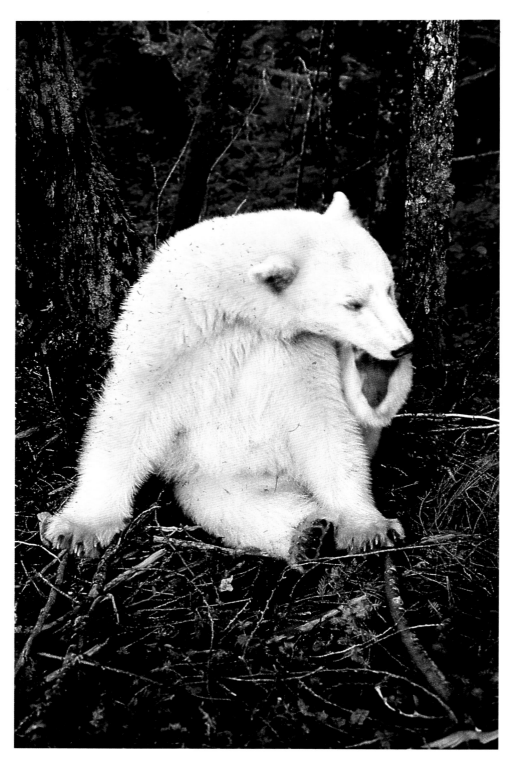

give his body all this care and attention, I suddenly became aware of how much larger he had become over the time we had known him. He had filled out with a thick layer of fat during the abnormally long

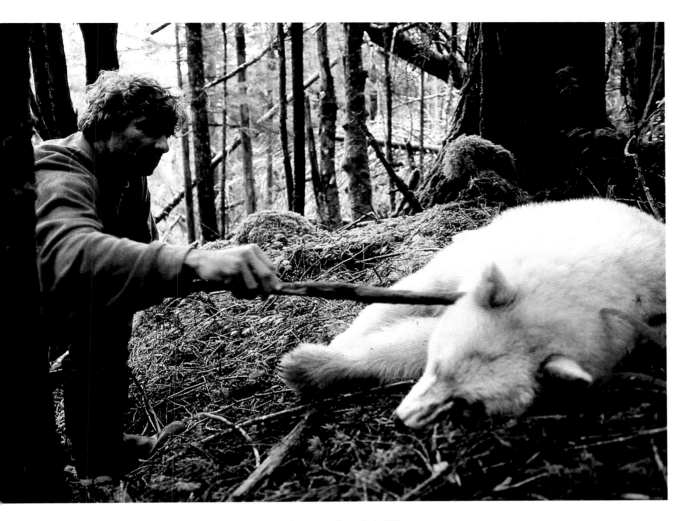

Helping the Spirit Bear with his scratching routine. © Jeff Turner

salmon run. I estimated that he must now weigh over 200 pounds (90 kg), probably a 25-percent weight gain since our first encounter with him a month earlier.

I was sitting near him and wondered if I might not assist him in his task. I reached out and scratched him with my fingers. Although he was quite gentle about it, he quickly brought his paw down on my hand in a way that said "no." I tried the same thing with a foot-long stick and was surprised and delighted at the totally different response. Soon he lay back, stopped his own scratching and let me do it all. He kicked repeatedly, the way a dog does when it is being scratched along its sides, and gleefully exposed his chin and ears for my ministrations.

When I was scratching the side of his nose, the Spirit Bear grasped the stick in his jaws. I gave it a gentle tug and he instantly sensed my

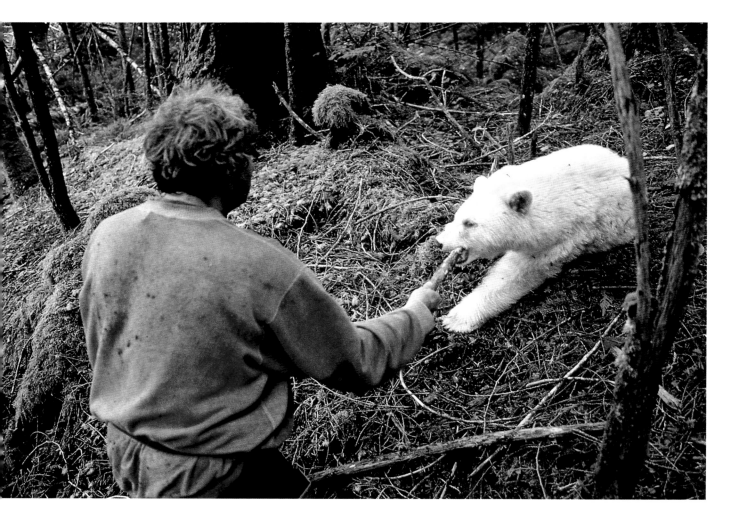

The scratching stick became a toy in a playful game of tug-of-war.
© Jeff Turner

playfulness. This clearly appealed to his imagination and he rolled over onto his stomach to give himself a better vantage point for the game. Going by what Sue's dog liked, I started to pull on the stick. He chomped down on it and the ensuing tug-of-war was great fun. I leaned back, putting all my weight into it while holding on with both hands. We were about evenly matched, pound for pound. However, when he sank his teeth into the stick about an inch from my hands, he gave himself quite an advantage. Occasionally he had to get a fresh grip but amazingly didn't bite my fingers. The harder I pulled, the more he would dig in and pull in his direction. We were sliding about with moss flying in all directions. He quickly learned to give sharp jerks with his powerful neck, which gave him a decided advantage and enabled him to win the stick.

Jeff also wanted to have a chance to pit his strength against the Spirit Bear's and took over when I lost. But the bear decided the game needed to progress into something else. I honestly don't think he knew

what that could be, but bears do play with one another with a fair bit of body contact. He suddenly let go of the stick and took a couple of steps toward Jeff, with a somewhat unsettling look in his eye. Jeff, in a startled voice, asked me: "What the hell is he doing?" as he started backing down the hill with the bear stalking him. "I think he wants to wrestle with you," was my feeble reply. Jeff wasn't about to have any part of it, and when the bear made a sudden lunge for him, he dodged to the side. The Spirit Bear's response was to bolt 20 feet (6 m) up a tree, only to come barreling down again with claws slicing through the bark, leaving bits of tree flying everywhere. He then ran up a slanting deadfall and leapt from it onto the top of a rock. Not being able to figure out how to play with us, he was just tearing around the forest, again much in the manner of a young dog bursting with exuberance and racing around in circles during a walk with the family.

Jeff was hurriedly trying to get his camera out of the pack to film this play. The Spirit Bear, thinking that perhaps this could be part of the game, jumped from a rock onto the camera pack and started to run with it. Luckily it was nearly empty and zipped up. When I managed to stop laughing, I ran after him, yelling at him to drop the pack. To my relief, he did and was soon airborne, leaping over a big log and landing flat on his stomach. He lay still, obviously trying to hide from me. I bent over to pick up the pack and he came flying at me, almost bumping into me, before speeding off to hide behind a big stump. It was so comical — the stump didn't conceal his body very well, but he made sure his head was hidden, possibly thinking: "If I can't see you, you can't see me." Jeff now had the camera out, and the bear crawled out of his hiding place, looking a bit dejected. I could imagine him thinking that these critters were pretty good at starting the fun, but no good at following through into the best part of the game.

I felt a bit sheepish, not being a quitter by nature, and decided to hold out the stick once more, half in an attempt to calm the bear down and half to uphold my honor. I could almost hear him say: "Oh, yippee! You want to play after all!" He came stalking toward me as he had done to Jeff earlier, but this time he made it clear he wasn't about to miss body contact. I was half expecting a knee or waist tackle, but no — at the last second, he stood up and slammed into me, chest to chest, his front legs outstretched as if to grasp me, his head to one side of mine. He didn't close his grip or attempt to grab me with his mouth. However, his weight sent me reeling backwards, crashing into Jeff, who was scrambling to get himself and the camera out of the way. We all almost

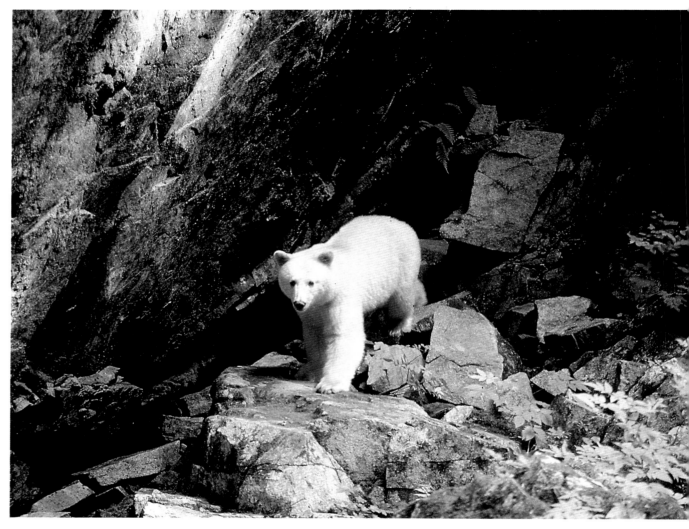

The Spirit Bear used this crack in the side of the canyon as a route to and from his favorite fishing spot.

tumbled over the nearby ledge, which had a 20-foot (6 m) drop. I yelled at the bear to stop just as he was looking as though he'd attempt another tackle. I couldn't believe it — he sat down. I explained to him that he was a bit rough, and that I was more fragile than he. He seemed to understand, slowly rose to all fours and headed back toward the canyon.

As exhilarating and amusing as this "play" encounter with the Spirit Bear had been, Jeff and I decided that we shouldn't encourage this kind of activity in the future. Even though we trusted him implicitly not to injure us deliberately, the bear was just too darn big to engage in hand-to-paw or chest-to-chest wrestling matches.

The rain had stopped and some beautiful light filtered into our green, mossy world. We wanted one last shot of the Spirit Bear coming down the canyon. We set up on one of the ridges ahead of him, trying to anticipate where he would come into view, walking toward the camera. His route was well known to us and we guessed correctly. We rolled film on him for the last time; the ocean was in the background and the light fell beautifully on his white coat. We didn't see him again that season. A week later we returned to Canyon Creek, but the weather had changed. A horrendous storm had preceded us, and there were no signs of salmon or bears. It was the end of September — we wouldn't see the Spirit Bear again until the following year.

▼▼▼▼▼▼▼▼▼▼▼▼▼▼▼▼▼▼▼▼▼▼▼▼▼▼

Final Thoughts

IN OCTOBER 1992 WE MET TO DISCUSS
the wrap-up of the first season at the Turners' home in Princeton,
B.C. The quality of film footage, together with what I had learned
while working with the Spirit Bear, surpassed our expectations. We
discovered, however, that the vision behind the film was changing. Over
the last few weeks of the field season, an uneasiness had crept into our
minds, and for me this feeling had almost crowded out the glory of our
success. Sue finally managed to put it into words: somehow we had to
show the world not only these fascinating animals, but also the magical
island habitat in which they lived. Our documentary film, to be titled
Island of the Ghost Bear, could be a powerful tool to convince viewers
the world over that Princess Royal Island was indeed a unique habitat
that warranted preservation in its pristine state.

We were now determined to capture the spirit of the island on film.
One way to reveal its landscape would be to employ aerial photography.
I longed to photograph the interplay between the sunlight and layers of
mist when day breaks in the valleys. I imagined flying over the high
reaches of the island, the places I had visited with the Spirit Bear in my
dreams, the places where no human had ever walked. Jeff knew I had
experience in flying ultralight aircraft, and he asked me about the
possibility of using one to shoot the aerials. We had had to rule out
helicopters. The ghostly qualities of mist and shafts of light we sought
usually occurred for only an hour or two once or twice a month. By the
time we could order in a helicopter charter, the light and clouds would
have long since changed.

After a few weeks of careful thought and research, I decided it was
feasible to use an ultralight in terms of the flying, but it looked like I
would have to build the aircraft myself. The cost of renting one was
beyond our means. Three important questions came to mind. Was there
anything on the market that had the performance and dependability

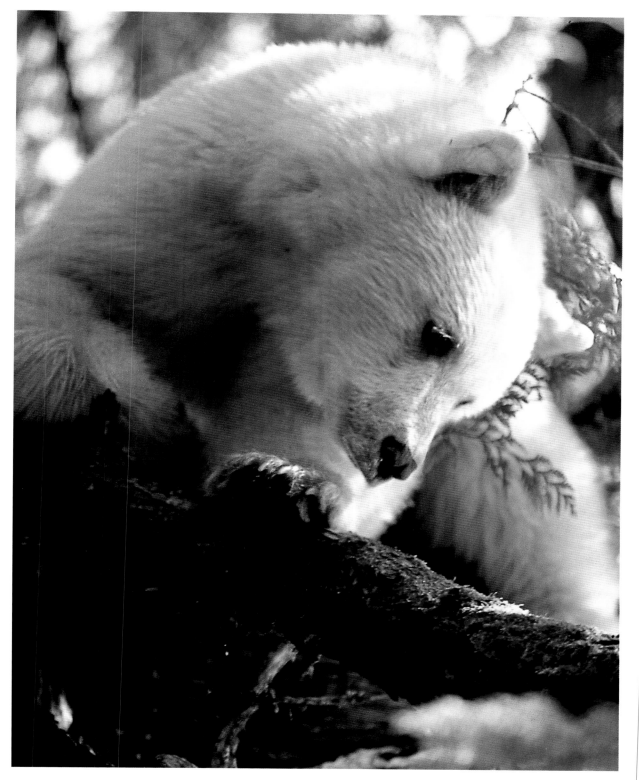

Trees are the most secure places of refuge for black bears. When they are cubs, their mother will often leave them in trees while she feeds some distance away.

A coastal inlet as the autumn rains begin.

needed to operate in a remote location? Could it handle the demanding shifts in wind, elevation and moisture levels? Would I have the time to build the aircraft myself? (For the Kolb ultralight of my choice, it was estimated that it would take two years of spare time to build. We began discussing this plan in November, leaving me only three-and-a-half months of concentrated building time, plus two weeks to test-fly the plane.) Finally, how would I protect the aircraft from the fierce storms when I got it to Princess Royal Island?

I telephoned Homer Kolb in Pennsylvania and was pleased to learn the Mark III Ultralite met the strength and dependability specifications I required. Plus it had been tested on floats. He recommended that I use a mono-hull inflatable float designed in Vancouver, which was so tough I would be able to beach it on barnacles without damage. First, though, I had to satisfy myself that it would be possible to protect the aircraft at our camp moorage. I decided to construct a floating dock that would rise and fall with the tide. It would have a ramp, and I could use the power of the plane to skid it on and off the dock. I reasoned that if I tied down the plane on the dock, with its nose pointed up the inlet where the gale-force winds came from, it would be secure even in winds of 70 knots.

I built the ultralight in my father's cottage. The dining room was the only place with enough space to assemble the wings.

The sixty-four-dollar question remained, however: Could I build the plane and have it equipped and tested by April? My workshop had been destroyed in a fire in 1990, which meant I would have to build the ultralight partly in the Hawk's Nest and partly in the cottage where I was wintering with my father. After much thought, I decided to go ahead with it. When the multitude of unassembled pieces arrived in mid-December, reality set in. I knew I would have to buckle down and work long hours every day to meet what would appear at times to be an impossible goal.

In the months that followed, Anthony managed to lure me out skiing only once. Eventually, having given up on skiing with me, he turned to helping in the construction during his spare time from university studies, providing valuable yeoman service. Throughout the winter my father was a model of patience. Each wing took ten days to build, and during this time we had to live around the aluminum frames, which took up most of the kitchen-dining area. Not even when he almost broke a tooth on two stainless steel rivets that showed up in his omelette one morning did he protest!

Fortunately, I surprised even myself by not making any major

blunders that would have cost precious time. The kit and instructions were so thorough and detailed, it was necessary to consult the Kolb Company only once during construction. To my great relief I experienced the same ease of assembly with the motor (a 65-horsepower Rotax), purchased from Buzzman Enterprises in Ontario. After three months of hard work, a team of helpers arrived to ensure the plane would be ready in time. Jeff and Sue came from Princeton, and my good friend Ken Nodge began building a trailer to transport the aircraft to Prince Rupert. When he wasn't working on the trailer, Ken helped me cover and paint the wings. Doug Murray, another friend and assembler of home-built aircraft, installed the instruments and tuned the motor. Miraculously, it all came together by April 13, and I was ready to make the first flight from a neighbor's grass strip not far from the ranch.

I knew of no person in the region who had any experience flying this model of aircraft, so I decided to do my own test-flying, even though the plane was different from anything I'd flown before. I had 150 hours of flying a different ultralight, but hadn't flown in the past six years. For me, there is no thrill quite like flying a machine that I have built myself, and this one was no exception. I wasn't prepared, though, for the power of the motor on takeoff, or the amount of left rudder needed to counter the torque. Once in the air I discovered a "tail heavy" problem. After half an hour aloft, I landed, not too softly but safely and with everything running smoothly.

After making the necessary adjustments, I felt ready to see what the ultralight could do in the field. I marveled at its power and quick response, and soon saw that it had all the qualities I needed in an aircraft for Princess Royal. Following a three-day trip to Prince Rupert, I installed the mono-float and the wing-tip floats called sponsons. I was a bit apprehensive about taking off from the water, and was also aware of some of the hazards associated with floats. Landing on glassy, still water presents a problem of depth perception because the water acts like a mirror. You have to resist trying to judge where the surface actually is, which is what one routinely would do when landing on the ground. Instead, the trick is to descend gently until you touch down. Often the contact is very much a surprise. Even after I became proficient at this, I once hit the water when I thought I was still at least 50 feet (15 m) above it.

Although I had consulted with experts and had done extensive reading on the subject, I felt unprepared and knew I was pushing the

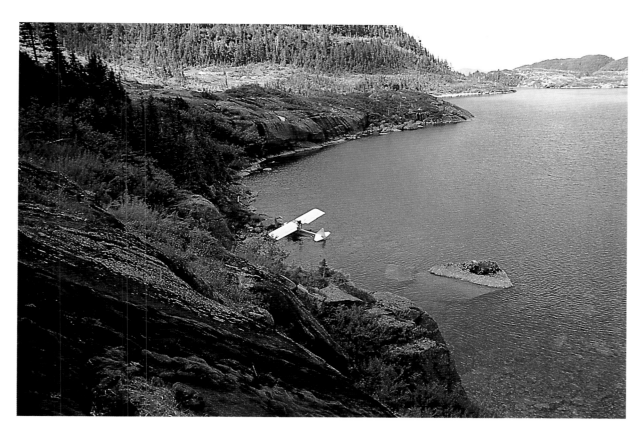

The ultralight gave me the freedom to explore where few people had been before.

limits of my personal courage. The other float planes tied up in the Prince Rupert air marina looked like the proverbial barnyard geese alongside my gossamer-like butterfly. The pilots of these ponderous beasts just shook their heads when I told them I intended to fly south to Princess Royal and work all season in such a remote location. Contrary to everyone's expectations, however, there were few hurdles that I couldn't easily overcome in the end. I tested the aircraft in strong winds, landed on surprisingly high waves, and the motor didn't so much as cough in the heaviest of rain. I was now ready to begin our quest to film the island of the Spirit Bear.

After waiting nearly a week for the weather to clear, I heard a promising forecast and set about loading my gear and 5 gallons (20 L) of reserve gas into the passenger space for a takeoff the following morning. I anticipated a two- to three-hour journey down Grenville Channel and over the north end of Princess Royal. Contrary to the forecast, the weather proved rainy and dull, but I finally departed, weaving my way through the columns of rain, and headed down the channel. I experienced some nervousness — the sea below was rough

As this photograph no doubt shows, I was proud of the plane and how well it worked.
© Maureen Enns

and the sky ahead dark — but I flew as high as I could, skimming under the clouds. At an elevation of about 4,000 feet (1200 m), I felt I had enough maneuvering room to glide to a safe landing should the motor fail.

A while later I could see brightness ahead and the sun reflecting off calm water, and soon flew into a magical world of shimmering light. My heart lifted for the first time in months. I had been weighed down by a task that at times had seemed impossible. My spirits soared even higher when I caught sight of the mountains of Princess Royal. Charting a course over the middle of the island, which gave me an opportunity to view its northern portion, I spotted Deer Lake beyond the head of Drake Inlet. I flew over many lakes and valleys, the names of which were unknown to me then. When I learned later that one drainage I'd passed over was called Paradise Valley, I thought it was a perfect name for this labyrinth carved through 3,000 feet (900 m) of vertical granite and featuring a lake-strewn valley floor where few had ever ventured.

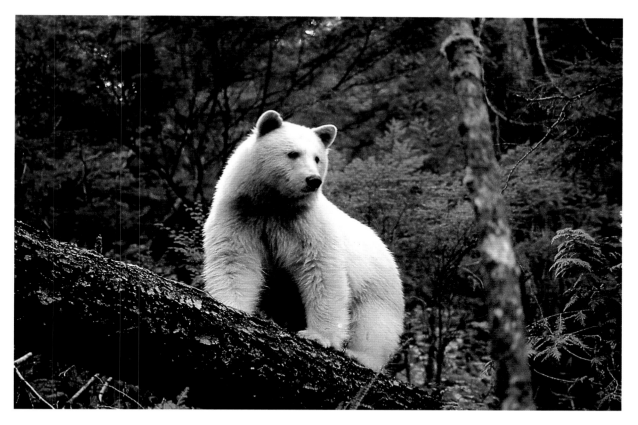

Our second year on the island was a chance to renew old friendships.

After an absence of six months, I was anxious to see my white bear friend again, and excited at the prospect of recording some of this sculptured island on film. Two-and-a-half hours into my flight the familiar landmarks of Camp Chelsea came into view. My thoughts wandered to Chelsea herself. Now eighteen months old, she would be as thrilled about exploring the intertidal world of her front yard as I was at being able to explore the island's remote lakes now that I had wings. It felt like a homecoming as I landed in the cove and taxied toward our camp, nestled under the giant Sitka spruces.

This was the beginning of a surreal summer. Jeff operated the camera and I flew the plane as we explored the hidden secrets of the little-known home of the Spirit Bear. Day by day, the fog, mist and shafts of brilliant sunlight provided a window into the rainforest, full of sparkle and mystery. Our reverie was broken when we received word that a license to log Drake's Inlet, at the north end of the island, had been granted.

Clear-cutting was scheduled to begin as early as August. The first

Taking off from Camp Chelsea with a heavy load.
© Sue Turner

Escaping to the world above the fog on a beautiful summer day.

complaints registered against the logging came from an unexpected source. During the previous year, B.C. Environment had issued a non-resident hunting territory to an outfitter who planned to cater exclusively to a group of twelve Swiss, German and Austrian citizens. Protesting to B.C. Parks about the logging, the spokesperson for the hunters demanded that the valleys be left undisturbed so that they might hunt black bears and wolves. Although hunting white bears remained illegal, it was all rather ludicrous considering that a female of either color could have both black and white cubs in the same litter. But I have learned that logic doesn't always dictate wildlife management decision-making.

The Raven's Guarantee was beginning to look very shaky indeed. For ten thousand years it had been able to keep its promise that this island would remain a safe place for the white bear. Was something about to end for us all? I felt I had to hold up my end of the bargain made with

the raven on the beach among the ancient Tsimshian fish weirs.

Since 1991, we had lived on Princess Royal Island for about thirteen months altogether, and I was confident that we had not significantly changed any bear's behavior through carelessness. The harmony and trust that we had enjoyed during hundreds of hours in the field and near camp had been much easier to maintain than I would have guessed prior to my knowledge of this special place. No bear had ever penetrated our camp for food or garbage, nor were inclined to do so. They had never been rewarded by so much as a morsel of food. In addition to our care in this regard, we also had an electric fence around the perimeter of the camp. To our knowledge, the bears rarely tested the fence and none had been inside.

Nothing ever happened to suggest that the trust we had built up with many individual bears had been broken. (The violent experience that Anthony and I had suffered in 1984 made me watchful for any signs of hostility.) I am convinced this was primarily due to our strict policy of never allowing bears into our food, which would have created expectations that could have led to trouble. As well as not being inadvertent providers of the bears' most important commodity, we hadn't fed them as a form of manipulation. I cannot emphasize too strongly my fervent belief that keeping human food away from bears is vital in avoiding problems. A bear that expects a hand-out in a wilderness setting is "Trouble with a capital T."

In addition, we always treated the bears with a carefully maintained respect. Jeff and I developed a presence around bears, an attitude that recognized their intelligence and interest in us, as well as ours in them. This interest and mutual recognition seemed to be all that was needed to establish a safe relationship with these powerful animals. Anyone who has worked with other powerful beasts, such as horses or bulls, knows that once you establish a certain rapport based on intelligent responsiveness, you can also be assured of a degree of safety, even though these animals are capable of seriously injuring or even killing a person at any time.

Vicki Hearne, a writer for *Harper's* and an animal trainer, is the only person I know who has explained this phenomenon to my satisfaction. She suggested that "the intelligent responsiveness of animals is for us one of the most deeply attractive things about them, not only because we are a lonesome and threatened tribe but because intelligent responsiveness is a central, abiding good." This quality in trainers, which some of them call respect, is what makes trainers attractive to

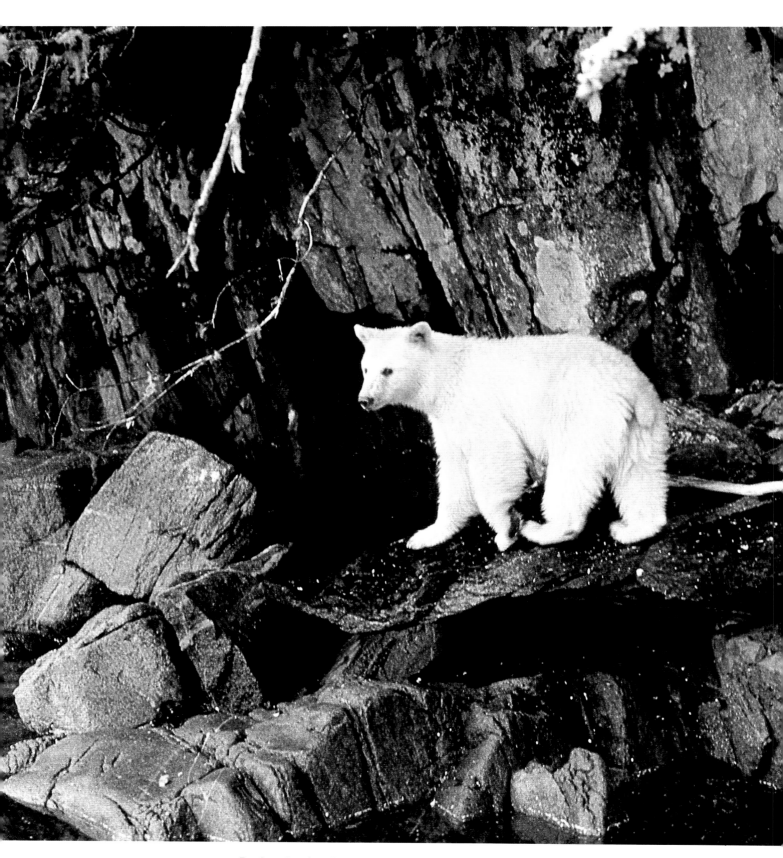

During the time I spent on Princess Royal Island, I counted nine individual white bears.

animals, and is perhaps the whole secret of "having a way with animals."

I recognize the difference between answering questions for oneself about the possibility of a different understanding and putting those thoughts forward as some new truth. The status quo regarding our present understanding of bears will see us safely through most of our encounters with bears, but will continue to be at the expense of the bear. If I have learned anything from my experience on Princess Royal Island, it is that almost all of the disharmony that we humans have had with black bears, and probably to a large extent with grizzlies as well, over our long and troubled history together, might well be traced to mistakes and mistreatment of bears by humans, not the other way around. In the final analysis, bears are remarkably forgiving of the sins of the human animal, while collectively we do not seem capable of displaying much understanding or patience toward them.

▼ ▼ ▼ ▼ ▼ ▼ ▼ ▼ ▼ ▼ ▼ ▼ ▼ ▼

By the middle of September there wasn't much left to do on the film. One of the highlights of the second season was again spending time with the Spirit Bear of Canyon Creek. It was as though we had not been away for more than a day when we again saw him — almost a year since our incredible adventure with him. He walked up and sat down a few feet away and looked as though he wanted to hear what we had been doing during the past eleven months. I would have given anything to have been able to ask, and hear the answer to, that same question directed at him. Whatever the story was, he looked healthy and bigger. A deep respect and friendship seemed to have grown between us, which I hoped would be reflected in the film.

Before we packed up our camp, I wanted to show a white bear to a couple of friends who had met

Doug Stewart in Kitimat, B.C., and were on their way to the island. Sid Marty was coming to do research for a *Canadian Geographic* article, "Ghosts of the Rain Forest." Maureen Enns was an artist and film-maker whom I had recently gotten to know when she interviewed me for her film, *Grizzly Kingdom: An Artist's Encounter*.

On the morning of September 13, I calculated where I might intercept them with my plane. There was low cloud at 7 A.M., but I finally found a small hole at the head of the inlet and climbed into bright sunlight. The mountains were free of cloud above the 1,000-foot (300 m) level, and I felt secure with many high lakes as possible landing sites if something should go wrong with the engine. By the time I arrived in Buttedale, the cloud had vanished below and I was able to look for Doug's boat. I had flown almost 75 miles (120 km) before I spotted him. Even from high above the water, I could recognize his boat from the way he towed his skiff. It was a gorgeous morning as I lazily circled down and landed beside the *Surfbird* on the glassy smooth emerald water. As the ultralight set down, Sid turned to Maureen and said, "Your ride, Ma'am, has arrived!" Maureen had done a lot of flying but to qualify her to be a passenger in my ultralight, I had to sign her up as a student. No previous flying experience for her equaled what she saw in the next few days.

After coffee and a visit with Sid and Roy Tanami, a photographer friend of Doug's, we took off for the hour's flight back to camp. We wouldn't see Sid for two days, due to the circuitous route they had to take. We flew along Gribbell Island, where over the years there had been sightings of white bears. From our count of nine individual white bears during the time we had spent on Princess Royal Island, we estimated a ratio of one white to eight black bears, although there was one valley that seemed to have a ratio of one to five, probably due to a concentration of the genes for whiteness in that rugged area. In Terrace, B.C., on the Skeena River, 125 miles (200 km) north, there is an estimated ratio of one to forty; in Hazelton, farther up the river, it is down to one in a hundred. Strangely, there are no Kermode bears in Kitimat, which lies between Princess Royal and Terrace.

Maureen and I were flying about a hundred feet (30 m) above the slightly rippled ocean surface in air that was as smooth as any I had flown in that summer. Straight ahead, I spotted the unmistakable plume of a blowing whale, a fine mist that rises 30 feet (9 m) in the air when the animal comes to the surface to breathe. Maintaining that course, we flew over four humpback whales. When I realized the

These humpback whales swimming off Princess Royal Island were photographed from the ultralight. © Maureen Enns

aircraft had no effect on them, I made a slow circle above as they made their way west. We could see them perfectly through the clear water, even when they were 50 feet (15 m) below the surface. They would descend to about that depth, and then slowly return to the surface to blow. It was one of the most beautiful sights I had seen during the many months spent on the coast, and Maureen was thrilled at the opportunity to photograph these giant mammals.

I wasn't as lucky when it came to showing Maureen a white bear. Sid, Doug and Ray saw one that afternoon from the *Surfbird,* but ten days passed before two white bears found us, right at camp. Summer-like hot, dry weather had persisted through most of September, but now the rain came and, with it, a mixed blessing. High water created a situation similar to what Jeff and I experienced the first time we had set up camp on Princess Royal two years earlier. The rain brought the bears to fish the boulder cascade once more. The problem was that Maureen and I had to find a window through which to fly to Prince Rupert sometime during the two days remaining before Stan Hutchings was to pick up our camp and equipment on September 25. Stan, a

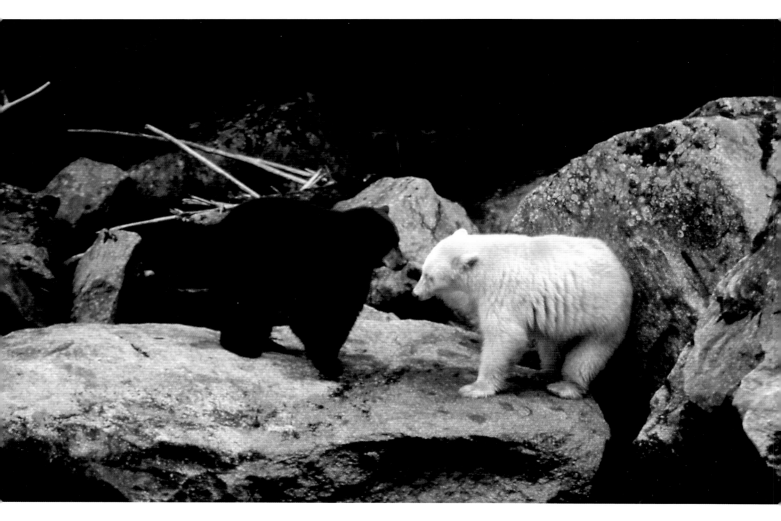

As I was photographing this rare exchange of gentle play, I realized that these were the siblings that Jeff and I had seen in the mist two years previously.

friend of Doug's, could do it only on that date. Although we could have flown out earlier, I didn't want to leave Sid and Jeff with the enormous job of dismantling camp. It was very important to Jeff, Sue, and me that we remove all vestiges of our presence there, restoring the area as closely as we could to the pristine state in which we had found it. The rain quit the evening before Stan's arrival, and we were burning some of the tent frames and floors in a large fire, well down the beach at low tide, when Jeff noticed a white bear fishing at the creek mouth. We all grabbed our cameras and paddled over in the canoes used around camp.

As we set up on a flat rock at the mouth of the cascade, the young male white bear was soon joined by a female black bear that appeared

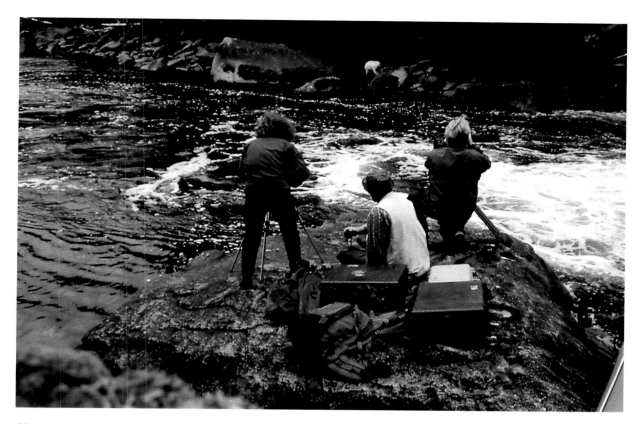

Maureen, Sid Marty and Jeff took advantage of our last day on the island to shoot some final footage of the white male sibling.

to be the same age. When the pair greeted each other in a rare, friendly manner, by playing and wrestling, it occurred to me that these were the siblings that Jeff and I had seen that misty evening on the log, two years before. They would have been weaned by their mother, probably at the age of one-and-a-half years. The siblings moved upstream to a place where they could both stand near each other, and watched closely as salmon struggled through the foamy water. Then, at the eddy below the rock on which they were standing, the male bear caught and shared a large chum with his sister. We were all smiles as we put away our cameras for the last time and paddled back to camp in the fading light.

The morning of September 25 was foggy but at 11 A.M. it began to lift. Maureen and I took off, between patches of cloud, and headed north toward a still ominous sky along the route that I had taken five months before when flying to Camp Chelsea. It was a jolting sight to see the clear-cutting in progress in Drake's Inlet, and I suddenly knew how critical our work might be.

Although they spent most of the year apart, these siblings came together to share the same fishing spot.

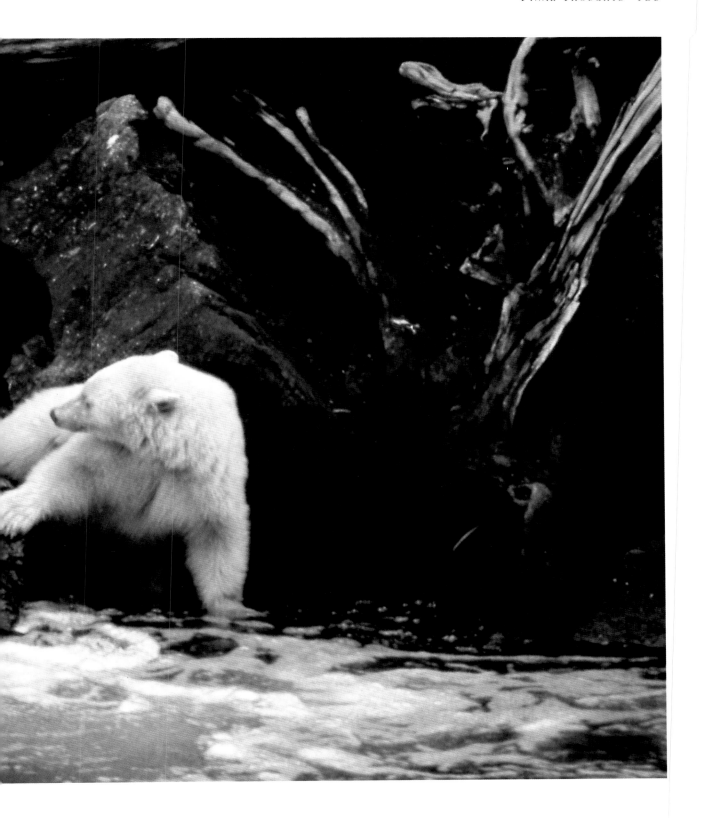

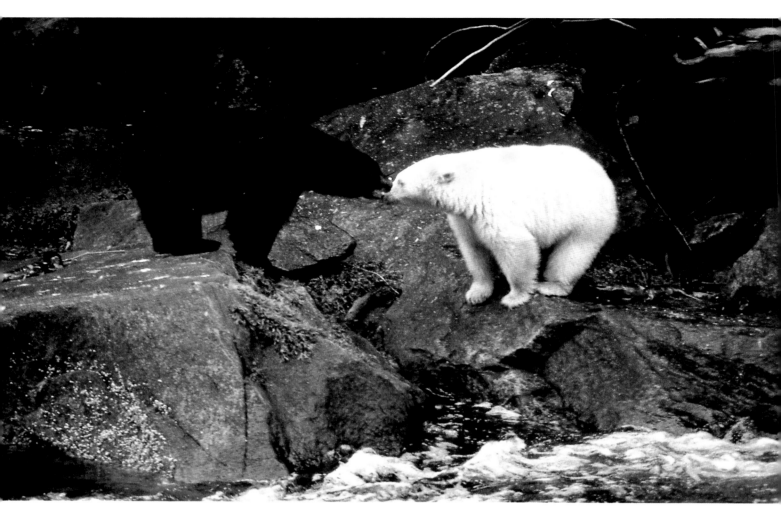

Above and opposite page: Getting to know each other again is easier for two bears that have shared experiences as cubs.

By conveying some of the magic of Princess Royal Island and its most elusive inhabitant, the white bear, through this book, our film and lectures, Jeff, Sue and I are also supporting the creation of a sanctuary on the island. For thousands of years, the Raven's Guarantee has protected the bears, the wolves and all the other plants and animals that have flourished in this unique habitat. People throughout the world now have a crucial opportunity to join in that guarantee.

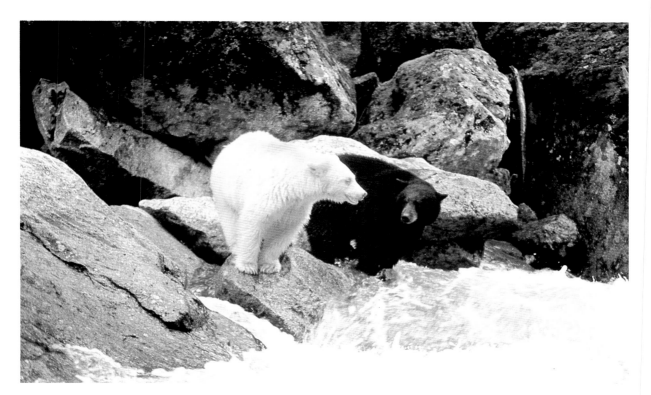

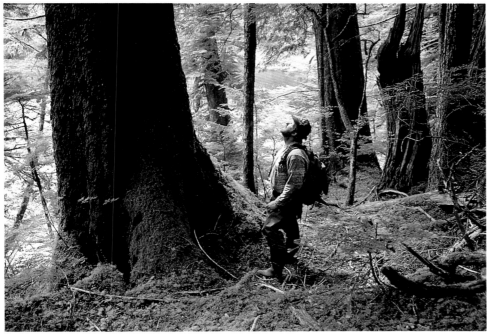

The forest of Princess Royal Island is vulnerable to logging. The largest trees, which are the most valuable to logging companies, mostly grow near the creeks, where their overhanging branches keep the water cool enough for salmon to spawn. Their removal would threaten the Kermode bear's food supply.

▼▼▼▼▼▼▼▼▼▼▼▼▼▼▼▼▼▼▼▼▼▼▼▼▼▼▼▼▼▼▼

How you can help

After working to help establish Canada's first grizzly
sanctuary in the Khutzeymateen Valley, the Valhalla
Society and the U.S.-based Great Bear Foundation are
now directing their efforts to protecting the southern
part of Princess Royal Island. The proposed Spirit Bear
Park (363,000 acres/147 000 ha) and the Green-
Khutze Inlet proposals (approximately 320,000
acres/130 000 ha), joined to other existing and
proposed protected areas, offer an opportunity to
protect the world's largest area of intact temperate
rainforest. Without massive public support, however,
these wilderness areas may be lost forever. We can
save this unique habitat, where white bears feed under
giant trees of great antiquity. For further information
on how you can help, please write to:

The Valhalla Wilderness Society
Box 224
New Denver, British Columbia
Canada
V0G 1S0

The Great Bear Foundation
Box 2699
Missoula, Montana
U.S.A.
59806

Index